滄海美術／藝術特輯2
羅青　主編

傳統中的現代

中國畫選新語

曾佑和　著

東大圖書公司

國立中央圖書館出版品預行編目資料

傳統中的現代：中國畫選新語／曾佑
和著．--初版．--臺北市：東大發
行：三民總經銷，民85
　　　面；　　公分．--（滄海美術，
藝術特輯；2）
ISBN 957-19-1900-4（精裝）
ISBN 957-19-1901-2（平裝）

1.書畫-作品集

941.6　　　　　　　　　　85001478

ⓒ 傳 統 中 的 現 代
——中 國 畫 選 新 語

著作人　曾佑和
發行人　劉仲文
著作財
產權人　東大圖書股份有限公司
　　　　臺北市復興北路三八六號
發行所　東大圖書股份有限公司
　　　　地　址／臺北市復興北路三八六號
　　　　郵　撥／〇一〇七一七五——〇號
印刷所　東大圖書股份有限公司
總經銷　三民書局股份有限公司
門市部　復北店／臺北市復興北路三八六號
　　　　重南店／臺北市重慶南路一段六十一號
初　版　中華民國八十五年四月
編　號　E 94020
基本定價　陸元陸角
行政院新聞局登記證局版臺業字第〇一九七號

有著作權，不准侵害

ISBN 957-19-1901-2（平裝）

「滄海美術／藝術特輯」緣起

　　民國八十年初，承三民書局暨東大圖書公司董事長劉振強先生的美意，邀我主編美術叢書，幾經商議，定名爲「滄海美術」，取「藝術無涯，滄海一粟」之意。叢書編輯之初，方向以藝術史論著爲主，重點放在十八、十九、二十世紀。數年下來，發現叢書編輯之主觀願望還要與客觀環境相互配合。因此在出版十八開大部頭的藝術史叢書之外，又另外出版二十五開的「滄海美術／藝術論叢」，把有關藝術及藝術史的單篇評論文章結集出書。

　　在廣向各方邀稿的同時，我發現以精美圖片爲主的藝術圖書，亦十分重要，不但可補「藝術史」、「藝術論叢」之圖片之不足，同時也可使第一手的文物資料得到妥善的複製，廣爲流傳，爲藝術史的研究評論提供了重要的養料。於是便開始著手策劃十六開的「滄海美術／藝術特輯」，儘量將實物及一手材料用彩色及放大畫面印刷出來，以供讀者研究欣賞。在唐、宋、元、明、清藝術特輯的大綱之下，編輯部將以機動靈活的方式不定期推出各種專題：每輯皆有導言，圖片附刊解說，使讀者能在最短的時間，對某一特定主題，有全面而深入的掌握。大

家如能把「藝術特輯」與「藝術史」及「藝術論叢」相互對照參看，一定有意想不到的結果與發現。

中西藝術之橋

　　曾佑和女士出生於一九二五年，幼年拜舊王孫溥忻、溥佺二人爲師，習傳統中國人物、山水，基礎深厚；一九四九年至夏威夷，旋遊歐美，畫風爲之一變，是中國最早能從傳統中走入現代的畫家之一。一九六五年，她自紐約大學畢業，獲藝術史博士學位，創作與研究兼修，理論與實際並重，而兩者均達到無比的高度，深刻精微並而有之，求之當代畫家，可謂稀若星鳳。

　　曾女士於一九六三年出版英文本《中國畫選新語》，率先以現代的眼光，重新瞭解中國傳統藝術，找出其中與現代精神相契合或相巧合的作品，爲中西傳統與現代，搭起藝術的橋梁，眼光獨到，立論精闢，三十多年後的今天，仍然擲地有聲，值得重讀。

　　編者初得此書於一九八六年，即有心將之重印出版，介紹給中國讀者。經過多年努力，來往通信，終於在今年得償宿願。曾女士不但慨允將舊作原版相贈，並另撰〈新版序言〉、〈新版導言〉及〈中國傳統藝術之我見〉，同時在下卷中，編次她自己的創作歷程，圖文並茂，極具研究欣賞價值。曾女士以其「掇

畫」名震中外，此處自道原始，彌足珍貴。

　　本書初印時，中文部分，因在美排版不便，便全以曾女士的榮楷原稿印出。曾女士的書法，端莊精嚴，眞氣充沛，直追古人寫經之體，求之當世，實不多見。故據原書，重新影印附於書後，以供欣賞。此書因部分成於三十多年前，行文語法，時過境遷，或有變異，需要訂正。曾女士授權給我，在排版時，稍加調整字句，以便閱讀；如因此而適得其反，有礙文義流暢，則罪全在我，還望讀者海涵。

目 次

Cover: By Young Wei-chüan (1885-1950?), a contemporary artist. The painting is dated 1942. A technique found during the nineteenth century, referred to as "chi chin", i.c., assembled brocades, generally depicts worn antiques. It looks like a collage but actually was painted by hand, most realistically.

封面説明：楊渭泉 (1885-1950?) 作。此畫作於 1942 年。畫法源自於十九
　　　　世紀，稱之爲「集錦法」：將碎錦及殘畫古書合畫一圖，遠看
　　　　似西方之「拼貼法」，近看方知是用超寫實的畫法而成。

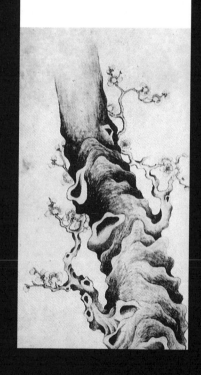

上卷

To the late Dr. Hu Shih

A twentieth-century gentleman, who, carrying the burden of the past and un-folding the possibility of the future, added a giant step to Chinese scholarship.

謹以此書悼念胡適之先生

一位二十世紀的謙謙君子，肩負傳統重擔，開創無限未來，爲
中國文藝學術向前跨出了巨大的一步。

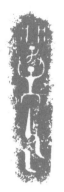

傳統中的現代

Foreword

This collection of Chinese pictorial motifs, a fraction of artmorale, makes no pretense other than to illustrate the lecture on which it is based. It makes no claims, nor does it offer an analysis; it is simply an attempt to capture poetic truth. Though only a small picture book, it has involved much work. I wish to express my gratitude to the University of Hawaii Press, especially Mrs. Aldyth V. Morris and Mr. William W. Stuart, who patiently went through every detail of the text. Mr. James Bryan helped with the layout and design. My thanks are also extended to Mr. Thomas Nickerson of the University of Hawaii Press and to Mr. Robert P. Griffing, Jr., director of the Honolulu Academy of Arts, who kindly supported the publication of this book. Also, to Gustav Ecke, my husband, who was always ready to assist whenever a question arose, my special thanks.

序言

　　這本小畫册原是五年前的一個演講稿，只是局部的選材及論理，推析不以斷言，引證時歸抒情，難免遺笑方家。承夏威夷大學出版主任及檀島美術院長慈惠，終於製版付梓，雖說是小畫册，印刷期間，竟耗時三、四年之久。毛瑞士夫人熱誠編輯，為方便讀者閱讀，盡量減少注解，因之中英文字，頗有參差，好在內容尚能締合。

　　關於書畫原件收藏者，多數零散不知下落，故宮古物部分，承蒙准許使用，多謝莊尚嚴先生。圖八「二婦圖」，檀島美術院藏。圖十七「大理石豎屏」，曾憲七先生藏；封面「集錦圖」，林遠梯夫婦藏，在此一併致謝。照相師為美術院佐藤政雄先生，中文則是著者手抄。

　　正當出版，胡適之先生訃聞抵此。先生於學術思想不辭入湯蹈火，按時弊一一加以指摘。正因嚮往之眾，故亦謗譽交加。偶與先生談國畫現狀，聆先生於中國學術上以進為守的苦心，就學者精神論，無先生前導，中國文藝斷不能變闢新天地。先

傳統中的現代

5

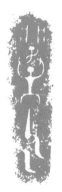

傳
統
中
的
現
代

The main difficulties with this book were those of sinological concern. The Chinese version, following page 73, though basically the same, is not an exact, word-for-word translation of the English text. Every effort was made to avoid footnotes in the interest of a popular and simple presentation.

The photographs were prepared with great care by Mr. Raymond Sato of the Honolulu Academy of Arts. Some of the items photographed are in private collections; it was sometimes difficult to trace present ownership. The majority are in the Palace Museum Collection. When I visited Wu-feng in 1961, Mr. Chuang Yen kindly permitted me to make use of this material. Plate 8, a portrait of two women, is in the collection of the Honolulu Academy of Arts. Plate 17, a marble slab, belongs to Mr. Tseng Hsien-ch'i of Boston. The original of the cover is in the collection of Mr. and Mrs. Y. T. Lum, of Honolulu.

Honolulu, 1962 *Tseng Yu-ho Ecke*

生以身作則，能化古能創今，能說能做，一生貢獻重大，中國
文藝史上自有實證。謹以此冊呈獻為
紀念追悼先生。

曾幼荷謹於檀香山一九六二年

傳統中的現代

傳
統
中
的
現
代

Introduction

There are certain modes in aesthetic standards, ever shifting with the changes in man himself. The man-of-today is continually searching, seeking satisfaction. And, as is so often the case, he frequently sees only that which he wishes to see.

Comparisons have been made between Chinese brush drawing and sixteenth-century European graphic art. Chinese still-life paintings have been considered alongside works by Carravagio, Chardin, Cézanne, and others. Chinese brush-work, too, has been related to the dashes and commas of impressionism or pointillism. And today, the Ch'an or Zen approach carries weight with some painters of the New York and Northwest schools in America, the school of Lyric Calligraphy in Paris, and others. One can always find common elements throughout art history East and West; they are as numerous as the differences.

導言

　　人世變遷，美術標準也隨各文化人事遷動，我們生於二十世紀，不能違背時代的演進，世界由於交通印刷接觸頻繁，美術範疇為之開放，我們今人與古人一樣諄諄追求美術真理。只是有時不免「以管窺豹」、或是「削足適履」，隨手定論，豈不可惜。

　　過去有美術理論家，比較中國畫的筆墨與歐洲十六世紀的鋼版、木版畫認為有相似之處。義國的凱若瓦咎、法國的沙但、賽占等靜物與中國畫中的瓜果畫、清供圖、瓶花寫生有相通之處。中國畫中的皴法點擢，與後期印象派的點劃非常相近。現在所謂的美國西北派、紐約派、巴黎的書法派、行動派，不計其數的前衛畫家，都深受東方禪理書法的影響。不論是畫面或是畫理、是古是今、是東方是西方，我們總可以找出其中相同之處不下於彼此相異之處。

　　法國詩人阿波羅列論文藝作風說：「汝豈能終日肩荷汝父之屍！」這句話是紐約畫家反對泥古守舊的口頭禪。其實石濤也說過很相同的話：「古人之鬚眉不能生在我之面目，古人之肺腑不

傳統中的現代

9

傳統中的現代

Apollinaire said, "You cannot carry your father's corpse around on your back," in a quotation often referred to by the New York school. Similarly, Shih T'ao, the seventeenth-century Chinese painter, said, "I cannot have old master's eyebrows and whiskers fasten onto my facestuff old master's intestines into my body." Experience and maturity should grow within one's self. If we handle the past or present experience as a dead thing, naturally, it is a corpse. But if we handle our experience past or present as a living, flowing thing, then it may be for us an eternal spring.

It is not the purpose of this brief discussion to enumerate all of the elements of coincidence and resemblance between traditional Chinese and contemporary pictorial art. And it would be too much to attempt to disentangle the philosophical and psychological relationships which may exist between the two. The intent here is merely to examine some lesser-known materials and some interesting efforts of Chinese artists of the past which have given or which could give inspiration to the artists of today.

Arthur Waley, in *An Introduction to the Study of Chinese Painting,* said, "Zen aims at the annihilation of consciousness, whereas art is produced by an interaction of

能安入我之腹腸。」經驗必須要本身親臨方才深厚，性情要發自衷心才能真切。如果今人只管盲目追古求今，不管是古是今，到手便成死屍。果能心通神會，不論求形求理，取古取今，都是源頭之水，活潑無竭無已。

這本小書主旨是列舉中國圖畫中之世界性，不能概括所有中國繪畫的成就，也不能包括所有與現代畫有相通之處的作品。至於哲理、心理、邏輯上之對比處，更不能詳細檢討。這只不過是選幾個例子，以顯過去中國畫家創作的探試，他們的成就，不可與囚縛成規者同日而語。只有深造原理的作品才是畫史中的精華，是有貢獻的美術，能夠超越時代及國際之範圍。

冊中收集例子，有兩個選擇的原則。一是取畫面的直覺感受，內行與外行都可以馬上看出其優越之點，在中國畫內可屬秀慧「外現」的一類。二是偏重於唐、宋以後的作品。中國畫理，自唐以來，發達全盛。其間創作精神不待絮言。中國畫論一向積極趨向「形上學」。因此，重「理」不重「形」。英國的亞瑟威禮說：「中國禪理是講究消滅『知覺』，中國美術則創作於知覺與不知覺交互之間。」事實不論世界什麼美術佳作，都是出乎知覺與不知覺之間。此處讓我們暫時分畫家為兩種：一種是全不自知的作家，這種創作奇才來自天然，作家自己不介意也不分析；其作品最易見的如民間工藝與上古工藝，無名藝術家而有驚心動魄的作品，既不傲世也不自炫。第二種是文智的推動。中國畫的主幹多受文人薰陶，自唐以來的大量作品，都

傳統中的現代

傳統中的現代

conscious and unconscious faculties." No doubt, the fine art of any period or locale has been thus produced.

Nevertheless, it is possible from this viewpoint to divide artists into two groups. One includes those who do not analyze themselves too much, who work in the spirit of pure intuitive creation. In this category, particularly, we find the primitive and the folk artists. In the second group are those who produce their art with much greater intellectual effort.

These are the two areas which have been stressed in the selection of examples for this book. The first is concerned with direct pictorial impact, where the effect is immediate. The Chinese painters in this area are the extroverts. A few designs in the largely unexplored field of Chinese folk art and applied art and examples of pictorial art earlier than the T'ang period (seventh century) are included here. While they may indicate the potential which developed more consciously in later ages, the approach of the earlier Chinese painters, on the one hand, and that of contemporary painters, on the other, is not the same. Although a conscious faculty is apparent in both, subconscious forces dominate the earlier, that is, the primitive and the folk artists, producing their quality of naïveté and innocence.

可算是文智的結晶。册中選取數種唐以前及民間的作品，是後期創作的潛在源淵。當然中國過去畫家的智性與新時代畫家的智性並不相同，但其中偏傾理智則如出一轍。中國畫中的「逸品」、「神品」，近乎天眞爛漫，不拘形跡；當代新派畫家也極力消滅「知性」，而其實是發自「知覺」而達於「下意識」。二者均是經知覺的牽使而後歸回於「無」。與上古、民間的創作是兩種天眞。這乃道家、禪家參測的「無」，不是嬰兒原始的「無」。

　　如今一般人每以爲「抽象」畫是二十世紀西洋的新發明。但美術歷史證明自古以來，各系文化都有「抽象」的企圖。在中國，「不求形似」之說，晉唐已開其端。現在畫壇新起風氣，輕易就要「前無古人，後無來者」，自謂是創新革舊的開山鼻祖。此輩看法比起一般依賴先人的態度，同樣有弊。眞正創作家追究眞理，畫面自然高卓新穎。只要是純粹創作，不論東西南北，常有萬象歸一的可能。能獨創出有意義的作品，方能成大家；本乎眞理，才能超脫人世遷變，不受時間地區的限制，永恆於人類美術史之中。

　　試以黃鉞的「二十四畫品」爲證。黃鉞的意見也有所本，推究淵源不勝其數。不過他寫的簡潔斬斷，證明中國畫直至近世，乃是理性追求，不是糊裡糊塗追求如何與古人同貌一模。古人計較筆墨，是以筆墨之「所得」全成象外之「性德」；講求作品的「正果」，不在定法立則。近代瑞士畫家保羅・克利說：「吾人每以道德觀念形容美術作品。」此說確合乎中國歷代書畫

傳統中的現代

13

傳統中的現代

The second area of Chinese painting illustrated here covers work done after the seventh century, when written aesthetic theory was well advanced in China. Much of Chinese painting is a consciously metaphysical art. The more intellectual artists, here exemplified by the Wen-jen school, now leading in Chinese painting, have nothing primitive about them. The conscious faculties emerge dominant.

Today we have the trend toward abstraction, acclaimed as the discovery of the twentieth century. Yet, it has been an element in the art of civilizations of all periods having similar outlooks and persuasions. Artists of today are more prone to emphasize their "rebellion" against their forebears than to admit an indebtedness to them. But either attitude is beside the point. To any creative artist, the aesthetic urge is a matter of natural bent or direction. The purest of any age or culture often meet on common ground. They find themselves together in that larger sphere of art which lies beyond the passing modes of contemporary thought. Their ultimate principles are perpetual, extending to the most distant eras of time and space.

The point, perhaps, may be illustrated by the very free translation of Huang Yüeh's[1] *Twenty-four Qualities of*

之鑑賞觀。此中容或有辭句撰寫的區別，然其理則一。「二十四畫品」固然有其時代性，然細嚼其中基本美學，除儒家理智「知覺」外，亦有不少道禪之玄說，值得大家細究。

傳統中的現代

按：黃鉞，號西齋、盲左(肓左目)、左君、左軍、左田。安徽當塗人。乾隆庚戌進士，戶部尚書。善書、工詩文、篆刻、亦善畫。生於一七五〇年，故於一八四一年。著有《壹齋集》、《附畫友錄》、《二十四畫品》等。

傳
統
中
的
現
代

Painting, which follows. Huang wrote in a stylized and lyrical manner. Essentially, he offers a general approach to the elements of painting as seen by one who is less interested in the method of creation than in the results.

In evaluating art, Paul Klee says, that we "place our work in an ethical frame of reference." How true it is. Problems of understanding range from simple questions of terminology through the metaphysical. And yet, while the conception of Huang Yüeh's treatise is eighteenth-century China, we find that he expresses ideals kindred to those of our own time and culure and shared by contemporary artists.

1. Huang Yüeh, painter, writer, and seal artist, 1750–1841. Born in Tang-T'u, Anhui. Known also as Hsi-chai, Mang-tso, Tso-chün, Tsot'ien.

二十四畫品

Twenty-four Qualities of Chinese Painting

黃鉞

By Huang Yüeh

傳統中的現代

I. Spirit Resonance

Of the Six Principles,[1] *Spirit Resonance is of first importance.*

Idea leads Brush. Wonder beyond the painting!

Like melody lingering on strings; like fog fading into mist.

Heaven's fresh wind, vibrating waves ⋯.

The apparent, large or small, becomes intangible, fluid.

Read ten thousand books,

Something may be revealed.

II. Divine Mystery

Clouds steaming; dragon transforming; spring and flowers become
　　　one on the tree.

In me, creation.

The heart? The mind? Which conjures all glory?

Following no previous masters.

Be the brush detailed or swift, devoid of clamor and confusion.

Sudden realization: this is all.

The ever-novice dissipates life, lost upon waves of trackless ocean.

一、氣韻。

六法之難、氣韻爲最、意居筆先、妙在畫外、如音棲絃、
如烟成靄、天風冷冷、水波濤濤、体物周流、無小無大、
讀萬卷書、庶幾心會。

二、神妙。

雲蒸龍變、春交樹花、造化在我、心耶手耶、驅役衆美、
不名一家、工似工意、爾無衆譁、偶然得之、夫何可加、
學徒皓首、茫無津涯。

傳統中的現代

III. Lofty Antiquity

Approaching close, a thing is not attained; in thought

it may not be captured.

Seen with eyes and touched in one's heart;

now caught, now discarded.

As in manner of rendering the Buddha's words,[2] in rubbings

from ancient script on stone drums,[3]

When snows of antiquity covered hills and buried deep

the ground unknown.

Did pristine man know Truth?

Nameless it is; who tells the secret?

IV. Seasoned Maturity

Ripened in supernal skill, illustrious soul ever grows.

Spirit lives fully. Calm and mature,

Not sated but rich, not overstriving but blessed ⋯.

As sparkles of mountain rain fall upon cloak, green-moist;

touching one's temples.

Captured in signs and images, it is ever elusive.

Yet, natural as the shade of pines,

The goal may be revealed.

三、高古。

即之不得、思之不至、寓目得心、旋取旋棄、繙金仙書、
搨石鼓字、古雪四山、充塞無地、羲皇上人、或知其意、
既無能名、誰洩其秘。

四、蒼潤。

妙法既臻、菁華日振、氣厚則蒼、神和乃潤、不丰而腴、
不刻而雋、山雨洒衣、空翠黏鬢、介乎跡象、尚非精進、
如松之陰、匠心斯印。

傳統中的現代

V. Solemn Majesty

Glance compasses miles in thousands; heart roams the immensity.

Force sunders the earth, lifts high the heavens.

It embraces the infinite; marked for pre-eminence.

Like hero on battlefield; like strong horse harnessed.

In poetry, Wei Wu[4]; in calligraphy, Yen Chen-ch'ing.[5]

Arriving is difficult but direction may be shown.

VI. Gentle Harmony

Late spring; sunset; evening glows in splendor.

Gentle rain with wind at remote post pavilion.

Melody of flute sounding soft through silence.

Be aware with gentle humbleness; beware lest we chew

 only dregs.

Formed, a thing is obvious; pursued, it is remote.

Not caught by force; destroyed through conceit.

With five spices proportion is ultimate.

五、沈雄。

目極萬里、心游大荒、魄力破地、天爲之昂、括之無遺、恢之彌張、名將臨敵、駿馬勒韁、詩曰魏武、書曰眞卿、雖不能至、夫亦可方。

六、冲和。

暮春晚霽、赭霞日消、風雨虛鐸、籟過洞簫、三爵油油、毋餔其糟、舉之可見、求之已遙、得非力致、失因意驕、加彼五味、其法維調。

傳統中的現代

VII. Perspective Infinity

White clouds in sky, breezes ever fresh;

Lute's melody lingers; gentle brook flows cool.

Regarding scene, whistling or humming ···.

Take silence to meet simplicity.

As with illness newly cured, sight lifts mind

 free from sorrow.

Like a poem by T'ao Ch'ien,[6]

Its air is autumn.

VIII. Archaic Simplicity

Great wisdom comes back to the naive; the basis of truth

 refound in simplicity,

Like that of pristine man clothed in grass and leaves.

Simple talk conveys essentials.

From the obscure bring the obvious; give soul to matter.

As bitter winter turns to spring.

Virile power held in restraint,

With mind concentrated and spirit penetrating.

七、沮遠。

白雲在空、好風不收、瑤琴罷揮、寒漪細流、偶爾坐對、嘯歌悠悠、遇簡以靜、若疾乍瘳、望之心移、即之銷憂、于詩爲陶、於時爲秋。

八、樸拙。

大巧若拙、歸樸返真、草衣卉服、如三代人、相遇殊野、相言彌親、寓顯于晦、寄心於身、譬彼冬嚴、乃和于春、知雄守雌、聚精會神。

傳統中的現代

IX. Superior Detachment

The wrist wrought with tradition, a fluency unhesitant.

Taste and thought; lofty excellence.

The inspiration roving free, sensitive.

God's palace high in heavens, hallowed mansion of deity.

Raised high, above mode or manner.

By themselves figures formed, images suggested.

Free expression, earth's unfathomed mystery.

X. Strange Originality

Creation meticulous, brush shirks no hardship,

Opening the trail, cutting path through weeds.

Tense inwardness yielding picture of inner vision.

Strange and wondrous in truth; heavens split open;

Chamber in cave-of-clouds; leisure at fairy isles.

A knock; wide opens the gate.

九、超脫。

腕有古人、機無留停、意趣高妙、縱其性靈、峨峨天宮、
嚴嚴仙扃、置身空虛、誰爲戶庭、遇物自肖、設象自形、
縱意恣肆、如塵冥冥。

十、奇闢。

造境無難、驅毫維艱、猶之理徑、繁蕪用刪、苦思内歛、
幽況外頒、極其神妙、天爲破慳、洞天清閟、蓬壺幽閒、
以手扣扉、表然啟關。

傳統中的現代

傳統中的現代

XI. Sweeping Swiftness

Rules many cause decadence; unbound by method is best.

Beyond thought, power speeds unchained.

A saying tells us, "Brush is plowing"; now a brush is in sweep.

Pours forth heaven and earth, ancient and new.

Dare freely from lightness of heart, nothing held back.

The command from within is not recklessness of accident.

XII. Splashing-Dripping

Blast whirls, rain pours and halts not for retrospection,

Venture into the unknown; so far, for the effort, and return.

From inspiration comes release; more brings exhaustion.

Do not overfeed with ink; starve the brush.

Fragrant wine intoxicates; poesy enhances.

Now, a sweep of the brush; ecstasy beyond words.

十一、縱橫。

積法成弊、舍法大好、匪夷所思、勢不可了、曰一筆耕、
況一筆掃、天地古今、出之懷抱、游戲拾得、終不可保、
是有眞宰、而敢草草。

十二、淋漓。

風馳雨驟、不可求思、蒼蒼茫茫、我攝得之、興盡而返、
貪則神疲、毋使墨飽、而令筆飢、酒香勃鬱、書味華滋、
此時一揮、樂不可支。

傳統中的現代

XIII. Unconcerned Coolness

Without thought for appearance, a bright glory glows.

Casually clothed, hair natural, unarranged; artless beauty is felt.

Stray brooks slanting; scattered hills in lonely woods; reeds and
water deep; white dew gleaming.

No powder and rouge.

Exquisite, like choice tea, fragrance lingers on tongue.

As with olive, haunting taste recurs.

XIV. Purity, Greatness

Bright moon on high terrace; clean shines flood of light.

Lute on knee; unknown fragrance fills the breast.

A crane soars high; plum blossom reflects upon pool.

Brush surprises mind.

Remedy for commonplace; talent enhanced.

Inhibition, irritation find no place here.

十三、荒寒。

邊幅不修、精采無旣、粗服亂頭、有名士氣、野水縱橫、
亂山荒蔚、蒹葭蒼蒼、白露晞未、洗其鉛華、卓爾名貴、
佳茗留甘、諫果回味。

十四、清曠。

皓月高台、清光大來、眠琴在膝、飛香滿懷、沖霄之鶴、
映水之梅、意所未設、筆爲之開、可以藥俗、可以增才、
局促瑟縮、胡爲也哉。

傳統中的現代

XV. Spirit Ingenuity

Ears and eyes admit richness; heart and mind hold the bliss.

When genius creates, wonder surpasses the conscious.

Nature unfettered grows on, rare in classics and history.

Yet, the small may aspire to measure the infinite.

Let such talent grow, stricture of rules

as in poems of Chou and Wei.[7]

XVI. All Wholesomeness

A straw mattress, the earth; a straw hat, heaven.

Ten thousand forms seen from afar, the square grows round.

Painting is creation; the principle, oneness.

In thoroughness is abundance; the wholesome is ever sound.

Harmony glows in splendor, leads the way to seasoned maturity.

十五、性靈。

耳目既飫、心手有喜、天倪所動、妙不能已、自本自根、
亦經亦史、淺闚若成、深探匪止、聽其自然、法為之死、
譬之詩歌、滄浪孺子。

十六、圓渾。

槃以喻地、笠以寫天、萬象遠視、遇方成圓、畫亦造化、
理無二焉、圓斯氣裕、渾則神全、和光熙融、物華娟研、
欲造蒼潤、斯途其先。

傳統中的現代

XVII. Recondite Intricacy

To the mountain not high, depth bestows majesty.

To the forest not dense, health-vigor gives grace.

Do not dwell on the spectacular and miss the essential.

Do not dwell on the appearance and lose the spirit of the brush.

Reach for the deep, but without strain.

Where it is hard to stay aloof, be generous.

XVIII. Limpid Lucidity

At quiet pavilion, rest refreshed by bubbling brook.

Lotus in fall, purple cluster is bright;

Blue pool still.

A fair lady in dainty dress, floating in gracious boat . . .

follow with eyes her drifting . . .heart throbs . . .

entranced composure.

Clear, as blossom; as water, lucid.

Shame on overpaint.

十七、幽邃。

山不在高、惟深則幽、林不在茂、惟健乃修、毋理不足、
而境是求、毋貌有餘、而筆不遒、息之深深、體之休休、
脫有未得、擴之以游。

十八、明淨。

虛亭枕流、荷花當秋、紫鴨的的、碧潭悠悠、美人明裝、
載橈蘭舟、目送心艷、神留于幽、淨與花競、明爭水浮、
施朱傳粉、徒招眾羞。

傳統中的現代

傳統中的現代

XIX. Vigorous Eminence

Sword forth from sheath; the arrow is drawn.

Penmanship possessed by skill-mortification.

Such thrust in painting captures not perfection; but, imbued with

vigor, soul alert, powerful.

Now proud descending; long sound soaring into space.

Generous grandeur is difficult; contemplation is vital.

Three lines may transform head into likeness.

XX. Terse Purity

Solidity depends not on volume; spareness has no need to mince.

Like night broken by day is this truth,

To achieve simplicity, begin with the complex;

To achieve purity, exclude petty decor.

Let others squander effort; get all in one stroke.

Suggest in minimum the mighty; find freedom in mediums.

Who sets the gauge? The birds of no-song.

十九、健拔。

劍拔弩張、書家所誚、縱筆快意、畫亦不妙、体足用充、
神警骨峭、軒然而來、憑虛長嘯、大往固難、細入尤要、
頰上三毫、裴楷乃笑。

二十、簡潔。

厚不因多、薄不因少、旨哉斯言、朗若天曉、務簡先繁、
欲潔去小、人方辭費、我一筆了、喻妙于微、游物之表、
夫誰則之、不鳴之鳥。

傳統中的現代

XXI. Proficient Accuracy

As Shih Chien,[8] setting a precedent of four errors,

For a painter, accuracy is only adequacy; the merely proficient

 is no achievement.

There may be perception, yet without spirit and insight,

So rich in book knowledge, so poor in one-word creation.

Careful and thoughtful, placing and planning; with one inch

 of tuft express the lore of ages.

XXII. Valiant Briskness

As though meeting a god, image veiled in the clouds,

In fine horse, discover mane and bone of best breeding.

A glow is before our eyes; life springs from its rhythm.

Eternal rightness restores mystery to the ordinary.

Flowers gorgeous in high noon; morning flight of legend's phoenix.

Halt a moment to ponder; growth is frozen.

二十一、精謹。

石建奏事、書馬誤四、謹則有餘、精則未至、了然于胸、
殫神竭智、富于千篇、貧于一字、慎之思之、然後位置、
使寸管中、有千古奇。

二十二、儁爽。

如逢真人、雲中依稀、如相駿馬、毛骨権奇、未盡諦視、
先生光輝、氣偕韻出、理將妙歸、名花午放、彩鸞朝飛、
一涉想像、皆成滯機。

傳統中的現代

XXIII. Airy Inspiration

Wingbeat of movement, soars high over multitudes.

Void of soul; trace of essence.

Inner strength is rare;

Structure little, spirit dense; appearance singular, intricate within.

Insight pierces mists;

With fire extinguished, incense lingers.

At dawn, cock crows across the top of the mulberry grove,

 in shrillness, far and clear.

XXIV. Captivating Charm

Captivating charm needs strength of foundation.

Who swims in the sea-of-ink, this concerns least.

Tameness may be outweighed by sweetness,

 feebleness saved by charm.

Yet, like enchanting daughter and beloved infant son,

Such delights bring warm contentment to person,

But to art, shallowness-absurd.

二十三、空靈。

栩栩欲動、落落不群、空兮靈兮、元氣絪縕、骨疏神密、
外合中分、自饒韻致、非關烟雲、香銷爐火、不火而薰、
雞鳴桑顚、清揚遠聞。

二十四、韶秀。

間架是立、韶秀始基、如濟墨海、此爲之涯、媚因韶誤、
嫩爲秀歧、但抱研骨、休憎面孄、有如艷女、有如佳兒、
非不可愛、大雅其嗤。

（錄自《美術叢書》）

傳統中的現代

1. The Six Principles of Painting, by Hsieh Ho (late 5th century): ① Spirit Resonance, for vitality of life movement; ② Insight of Brushwork, to indicate bones of structure; ③ Careful Drafting of Object, to give likeness; ④ Adaptation of Color, to fit character of object; ⑤ Planning and Design, for thoughtful composition; and ⑥ Accurate Drawing, transfer model to Painting.

2. The style used in early Buddhist inscriptions is most concentrated, with very abridged grammar. Expressions are colloquial without being crude and have an archaic simplicity.

3. The famous stone drums of the Chou Dynasty with ancient seal inscriptions were until recently preserved in the Academy of Learning in Peking. Plate 11 is a rubbing from one of these drums.

4. Wei Wu was Ts'ao Ts'ao, father of Emperor We Wen (early third century). His poems exemplify the most majestic spirit.

5. Yen Cheng-ch'ing was Court Censor during the 8th century and was famed for his honesty and integrity. These qualities of dignity as expressed in his handwriting were widely imitated; his pre-eminence created a writing style.

6. T'ao Ch'ien, a poet of the fourth century, wrote poems with a detached attitude, achieving a uniquely plain and natural style.

1. 謝赫六法（五世紀末）①氣韻生動，②骨法用筆，③應物象形，④隨類賦彩，⑤經營位置，⑥傳移摹寫。

2. 早期佛經行文之風格精簡扼要。用語俗而不野，十分古樸。

3. 周代之石鼓，上刻大篆，現存北京研究院。其拓本見圖十一。

4. 魏武指曹操魏文帝之父（三世紀初）。曹氏之詩，以氣象雄渾著稱。

5. 顏真卿爲八世紀時唐御史大夫，以正直精忠聞名天下，其書法中有正氣貫穿，自成風格，爲後世所法。

6. 陶潛爲四世紀時詩人，詩風飄逸，簡樸自然。

7. 此引西元前五世紀詩人屈原之詩；其他則引西元六世紀劉勰之詩。這些詩，皆自由之作，成於詩律嚴整之前。

8. 石建，西元前二世紀名臣，奏章中誤寫「馬」爲「四」，他人效之。

傳統中的現代

傳統中的現代

7. Refers to two poems, one by Chu Yüan of the late Chou period (fifth century B.C.) and the other by Lu Chüeh (early sixth century B.C.). These are freely inspired works, written at a time when poetry was unbound by rigid styles or formulas.

8. Shih Chien, a leading statesman of the second century B.C. When he wrote a report containing one error, he set a pattern, other report writers of the time slavishly copying the same error into their reports.

畫選

List of Plates

傳統中的現代

1. CAT.

Painting. Artist unknown. 12th century.

Chinese painting is known to be first and foremost an art of line.
This picture may be linear, but that is not its essential quality.
Chinese painting of the Academic School is known for its high regard
for subject matter, but what impresses us here is the fact that the
artist has achieved a naïveté of style which reminds us of the cat in
Alice in Wonderland. As Paul Klee says: " By the mere mastery of the
media one can depict things so cogently that they can achieve even
the more remote dimensions and results in figures or objects."

圖一　宋　無欵玉奴圖

中國畫講究線條，此圖雖工細，並不以線條誇張為主；院畫中十
分注重形似。然此畫使人佩服之處不在逼眞。這張畫的長處是作
者本身與動物的天眞融洽而一，童稚癡純，彷彿《阿利思漫遊奇
境記》中之貓、《西遊記》中的豬八戒。保羅・克利說：「畫法精練
到極處能通神妙，其意趣高深出於形象之外。」正可為此畫評語。

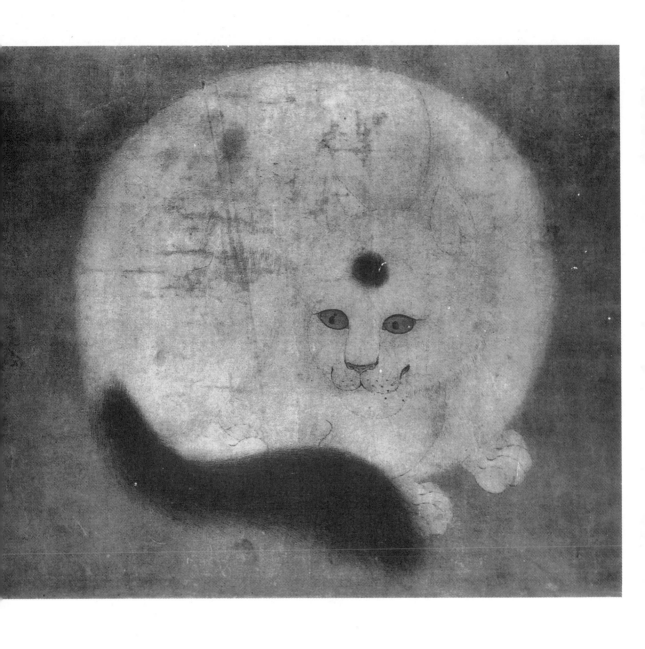

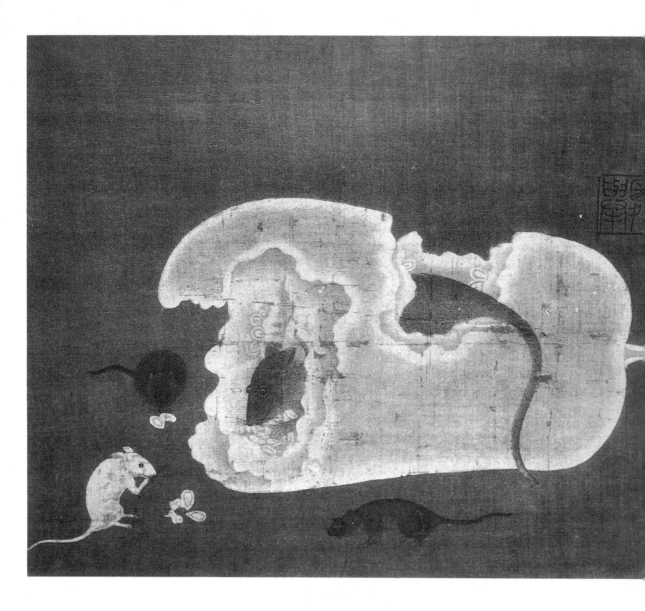

2. **MICE.**

Painting. Attributed to the Yüan painter Ch'ien Hsüan. 13th century.

This, like the previous painting, makes full use of folk subject matter and folk quality; it is a "mother-and-children" portrait of rare charm. As Huang Yüeh says: "Life springs from its rhythm. Eternal rightness restores mystery to the ordinary."

圖二 群鼠圖

傳元錢選筆。貓、鼠家常經見之物，雖鼠之微、其間母愛流溢，不如說是「母子圖」。黃鉞說：「氣諧韻出、理將妙歸。凡情細故都有深奧。」

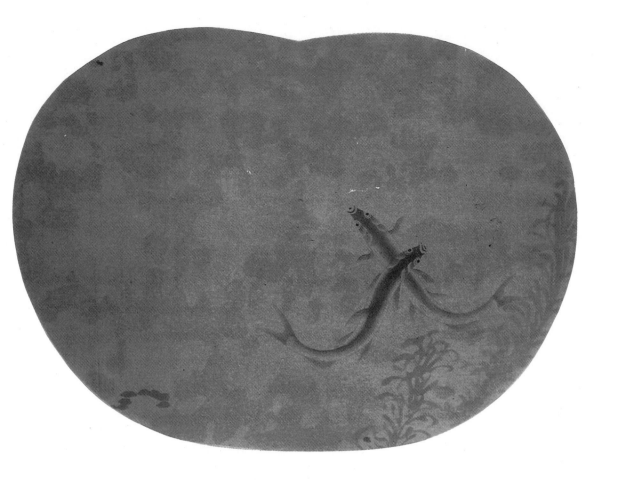

3. FISH.

Painting. Fan An-jen. 14th century.

This painting has an exquisite feeling for, and mastery of, space and design, which is still the concern of modern graphic art. "The thing itself, without being the thing, an image focused in the mirror of the mind and yet identical with the object" —these words of Goethe express a Ch'an concept of art.

圖三　魚戲圖

　　傳元范安仁筆。「物非物、物映心鏡、而爲物化」。是德國文豪歌德之語，很有禪家或《南華經》的味道。此畫經營位置精簡，仍爲一代設計之模範。

傳統中的現代

4. FOUR SPIDERS.
Painting. T'ung Yü. 18th century.

It made no difference to T'ung Yü whether his picture was covered with paint or signs, or consisted of only these four dots—it reached the same fulfillment. As Huang Yüeh pointed out: "Solidity depends not on volume. ...To achieve simplicity, begin with the complex; to achieve purity, exclude petty decor. Let others squander effort; get all in one stroke. Suggest in minimum the mighty; find freedom in mediums." As Paul Klee says, "Art does not render the visible; rather it makes visible." There are many ways to render the invisible.

圖四　清　四喜圖

童鈺戲筆。此圖雖用轉聲，而此四點足抵千山萬壑，用不著塞天塗地以成全章。黃鉞所謂的「厚不因多、薄不因少、喻妙於微、游物之表」。保羅‧克利說是「藝術不應倣明而顯見之物、應當啟發目所未見者」，表現畫外之意有種種路徑。

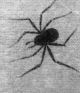
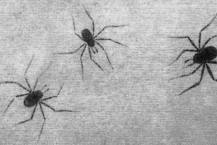
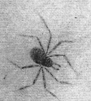

傳統中的現代

5. STILL-LIFE. INSCRIPT PAPER.
Painting. Chao Chi-ch'ien. 19th century.

Such a still-life would have found response in Juan Gris. Wang Wei, an artist of the 4th century, says, "Soul itself has no form; it dwells within a given form. Eyesight is limited; its scope is small. A painter holds a brush trying to record images from the universe. Through the thing painted, he opens people's eyes. In his pictorial arrangement, he creates life; in his form, he endows it with soul."

圖五　清　趙之謙作符條

晉王微云：「靈無所見、故所託不動、目有所極、故所見不周。於是乎以一管之筆，擬太虛之體、以判軀之狀，畫寸眸之明。……橫變縱化，故動生焉。前矩後方而靈出焉。」一小摺方生靈勃發。法國、黃歸士一生注力靜物摺紙，與此心照。

午時條 書粘壁上
村童也要弄紙業時
到門前條子出執為赤
口為白舌一間泫然無
可說但說向束有風氣
不曾識得其中意雖
然不識蟆與蛇却識先
生畫理產蓉紙千年不
濘墨豈有裝裏一樣
耶先生大笑子勿疑我
書不比輕薄兒力透紙背
知未知汝書頗頗盡消滅
消滅即在轉暄時堯口舌
烏足噬

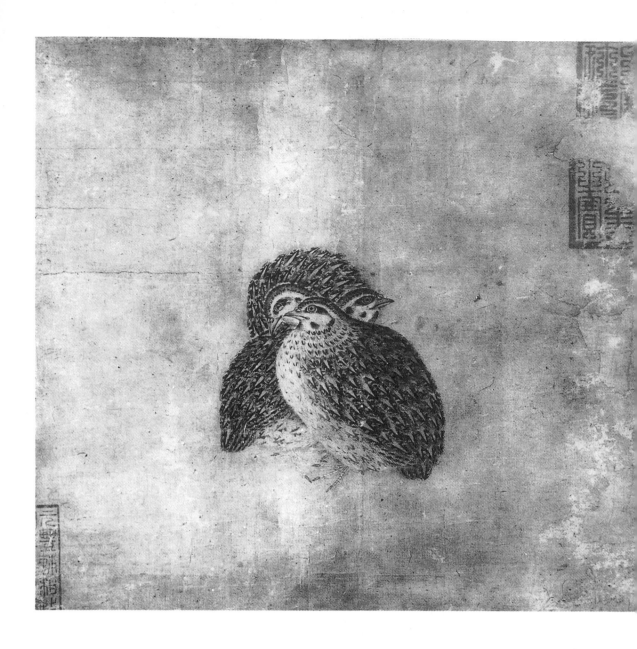

6. THREE QUAIL.

Painting. Li An-chung. 12th century.

The quail, clustered into one compact form, show the painter's ability
to articulate. "Tense inwardness yielding picture of inner vision."
There is present here the irrational element which reminds one of the
surrealists.

圖六　三鶉圖

　　傳宋李安忠筆。三鳥偎擁成一團，設意特妙。羽毛底細紛雜，目
　　啄森然凝遠，大有「超實物」畫派的奇鬱作風。黃鉞則謂之「苦
　　思內斂、幽況外頌」。

7. PLUM BLOSSOMS.

Painting. Ch'ien Tu. 18th century.

In contrast to other plum-blossom paintings, the painter here is more interested in the weird shape of the tree trunk. He seeks to capture the spirit of "high antiquity," with apparent "persistence and agony."

圖七　清　錢杜作梅

通常畫梅，以花姿挺秀爲勝。錢杜此圖出自老蓮。虯齟紋結、骨眼睜曉，意義全不在梅花，其高古之意與堅勁有連繫。

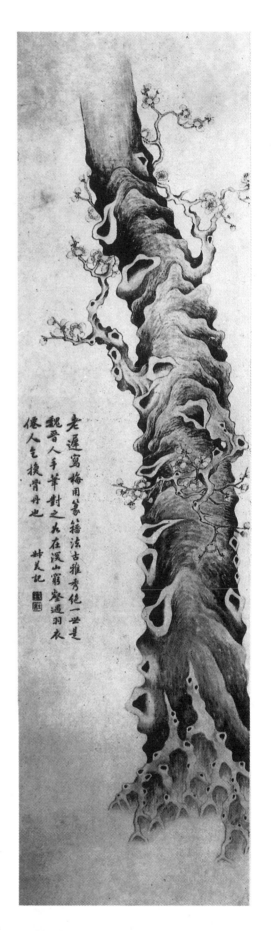

傳統中的現代

To consider further the folk elements in art, the term "primitivism," as commonly defined, has two current applications. One describes the art of non-literate cultures. The other covers work done by artists of the more highly developed civilizations, but with the deliberate or intentional "element of naïveté." Folk artists in the Far East are not by any means primitive in technique. They are extremely competent and their work is not removed from contemporary intellectual art. However, they produce their work with a group concept, with personal feeling swept clean, devoid of individuality. Their simplicity, pureness, the collective experiences, and the flavor of the soil are instinctive and innocent. But by its very nature this work is symbolic and highly stylized. Such virtues have been much admired and much explored by creative artists.

言及民俗原素、所謂的「古拙藝術」、並不是指作者本身智慧。普通兩種習慣用法：一爲指不曾開化民族的作品；另一種爲作品倶有極「樸拙」的體裁。民間藝術在東方以技能講是極盡奇巧，也有大量文智的滲入。概而言之，民間作品是聚集世襲經驗，本乎良知，無個性表現；但另倶一派純直，有集合的閱歷、水土的粗健氣。天眞爛漫不求甚解，尤強象徵，極形式化。自我表現的創作家又因之收取其性。

傳統中的現代

傳統中的現代

8. PORTRAIT OF TWO LADIES.
Painting. Artist unknown. 17th century.

Here is a return to the folk element. Portrait painting of this kind
has kept close contact with the people generally and thus preserves a
strong folk quality. As in figure paintings by Grant Wood or Henry
Rousseau, the stiff, exaggerated pose of the two women, along with
the simple setting, establishes the mood of the painting.

圖八　康熙　無欵二婦像

中國人像，明、清以來近民俗畫。其中人物據謹呆正，恰是可愛
之處。美國格軟・悟德便專工這種侷窘老成之態。

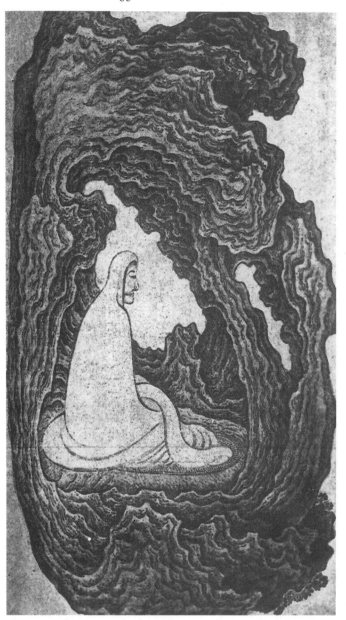

9. SEATED FIGURE.
Painting. Wu Pin. 16th century.

In the previous painting one may still doubt the awareness of the artist, but in this work the artist's effort to be primitive is obvious. The elongated features of the subject recall, in the Near East, the Byzantine style; in the Far East, sculptures of the Six Dynasties. What the painter attempts to achieve is "Great wisdom that come back to the naive. ...Virile power held in restraint." This painting has the quality of "archaic simplicity" exalted by Huang Yüeh.

圖九　明　吳彬十六應眞之一
　　　前者人像還近乎民間畫。以明眼
　　　取樸拙，國畫中不勝其舉。羅漢
　　　自貫休後吳彬獨攻其長。「返巧爲
　　　拙、知雄守雌」。羅漢的強篤，正
　　　是黃鉞樸拙之頌。

10. SEATED FIGURE, LOHAN.
Painting. Chou Hsi. 18th century.

The painter's design here shows no intentional primitivism, but nonetheless it has a strangely powerful impact on the beholder. Snatching branches entwine the Lohan, as in the "Temptation of St. Anthony." The painting reminds us of the work of Ben Shahn.

圖十　清　女畫家周禧阿羅漢十尊之一
　　　這件作品細緻如織、但也有奇闢之意。四樹擄擒、如蛇蝎、如
　　　「聖安東尼之誘惑」。魔障挑撥、剛烈耿悕。

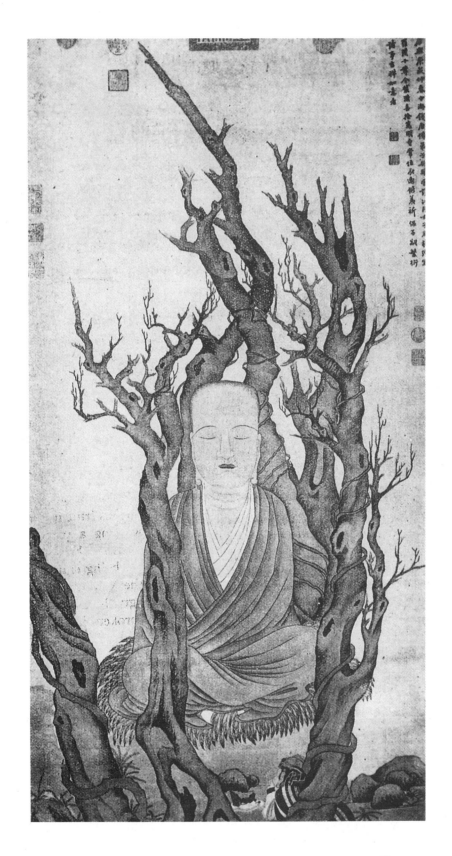

傳統中的現代

Archeological objects as seen in the following plates have

also inspired more modern artists. In Renaissance Italy,

Leonardo da Vinci was impressed by the patterns on a

moldering wall; so also was the thirteenth-century Chinese

painter Sung Ti. Sung Ti hung his unpainted silk on a moist

old wall. After some days there appeared the design of

concave and convex surfaces in which he found his landscape

composition. Mi Fu, of the Sung Period, playfully painted a

picture using the sponge part of a lotus fruit in place of a

brush. And Wang Yang-ming walked upon his silk wearing a

pair of new grass sandals; from this, with some added touches

of brushwork, he produced a flower painting. Still other

devices have been and are being employed utilizing the

random patterns of the unexpected. On the other hand, there

is an old saying which describes the summit of a beautiful

calligraphy as being like "the pattern produced by a roof

leakage." or that of a "broken jade hair ornament."

Penmanship may capture the beauty of the accidental

rubbings from bronzes, stone, and bamboo, actually an early

form of lithographic work, were treasured by connoisseurs.

Apart from their important historical and documentary value,

they were highly regarded for aesthetic reasons. The aging

surface textures produced their own patterns.

周石鼓文，是中國最古的長篇文字。這種古文提供時代畫家不少新意，殘跡蝕痕儘成章采。當初宋朝宋迪掛素絹於南牆，數日後絹面凸凹成形，宋迪乃隨勢而成山水。義國古畫家里歐那多‧大文齊也曾採用舊牆斑跡。中國書法絕境有「折釵骨、屋漏痕」之意，這都是取「天設地造」、遇跡成形，點手成金之妙。唐王洽潑墨成章；宋米芾漬蓮房作圖；明王養蒙著草履踏絹而成花卉，如今多少時代畫家、盡平生機智取這「偶而天成」不期然而然的作風。

傳統中的現代

11. ANCIENT STONE DRUM INSCRIPTION.
Rubbing. Artist unknown. 9th century B.C.

In addition to the inscription itself, the rubbing brings out the texture
design of the weathered stone surface. It has been taken from one of
the famous inscriptions on stone in drum form, believed to be the
earliest texts in length existing in China, dating back to approximately
the 9th century B.C., the Middle Chou Period.

圖十一　古代石鼓文
　　　　拓本，作者佚名，作於西元前九世紀。是周朝中期的文物。

12. LANDSCAPE.

Rubbing of an engraving from sculptured stele. Artist
unknown. 10th century.

Found in Canton, this engraving shows peach trees in blossom over a
river. One can follow the accidental pattern out of which the
composition grows. Such suggested designs are superbly understood by
Chinese craftsmen, as may be seen in the jade objects of the Neolithic
Age and, equally, in more recent ornamental jade hangings or snuff
bottles. The ideas of the "objet-trouve" and the "objet-modifie" of
modern artists belong in this category.

圖十二　南唐宮女墓碑

　　桃花流水，章法隨石紋而出。此種巧技中國歷代玉工最善其長，
視玉石形狀方圓大小、顏色布散，因而成花果魚蟲。自上古商
殷純幾何線狀之圭璧禮器至近世之鼻煙壺玉垂什物，曲盡其妙。
向來這種順形而出的手藝類歸工匠，然而其審密之處，正是文
人「神來」之品。

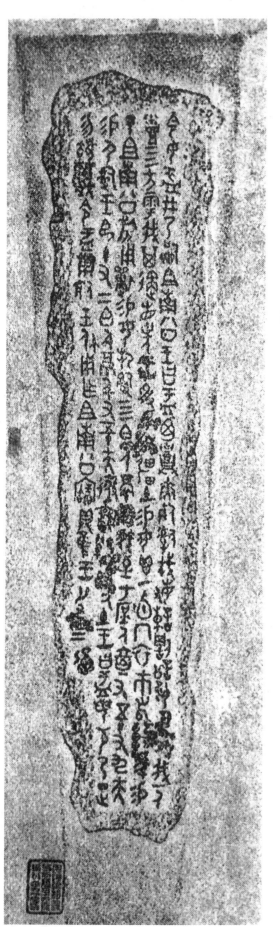

13. ENGRAVED BAMBOO.
Rubbing. Chang I-ju. 19th century.

Of hundreds of typical rubbings only a few examples can be shown here. In this rubbing an abstract pattern is derived from the texture of the aging material, while its pictorial significance is man-made.

圖十三　清　張揖如竹刻石鼓文

金石搨片久爲收藏家保重。除其歷史性外，斷箋殘篇，均有神韻。動人之處在乎浮面鱗剝之狀、脫落缺實、自成組織、百象窮生、恍然遠近，與近代石印畫相等。此竹刻倣搨片而再搨，難辨是文是圖，作家之心顯而易見。

14. BAG-SHAPED DESIGN.

Rubbing from an engraved inscription on reverse side of ink stone. Artist unknown. 12th century.

The basic bag design follows the shape of the stone itself. Here the intentional and the accidental each plays its part, but the importance is in the final result. A colophon was added by Emperor Ch'ien Lung in the 18th century.

圖十四　硯背浮雕　硯一

宋刻，有乾隆御題。緘囊之形出自石狀，其僅一無二的章法是天助是人智。單純而深厚，是「幾何抽象」的基礎。

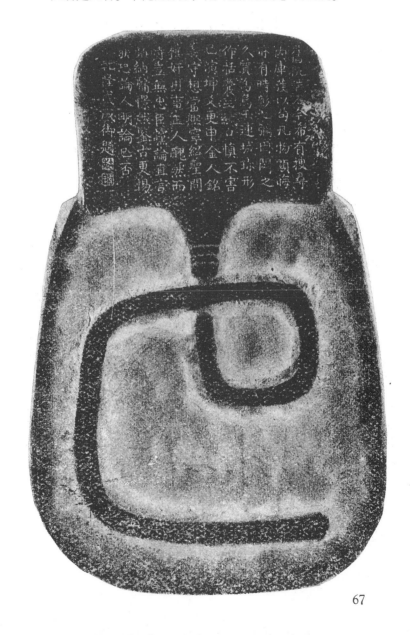

傳統中的現代

傳統中的現代

15. BIG EAR-SHAPED DESIGN.

Rubbing from an engraved inscription on reverse side of ink stone. Artist unknown. 17th century.

The stone with this weird design belonged to the 18th-century scholar Chu Chu-ch'a, and is as ingenious as it is fantastic.

圖十五　硯二

　　爲大耳、清朱竹垞收　彷彿荒謬，偏擊正著。具有機敏能遷石爲大耳者必是大家。

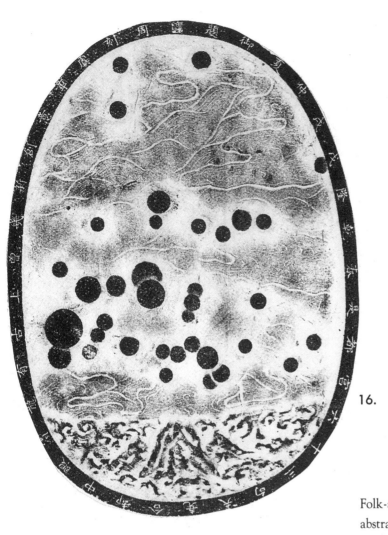

16. REPRESENTATION OF EARTH AND SKY.

Rubbing from an engraving on reverse side of ink stone. Artist unknown. 17th century.

Folk-art symbolism can be extremely abstract, at times with great exaggeration of the motif. Here the dots on the stone natural features, became giant stars.

A tiny island represents the earth. In the border surrounding the design, Emperor Ch'ien Lung wrote this comment, "The astronomy of the Yü engraved by the Chou—how original the idea! Could this be from the dragon dignitary of yore? The image from his eyes accords with the words of the ancient sage and so filled the Spring to the whole Palace of Thirty-six Courts."

圖十六　硯三

為康熙間雕。民間作品善誇大主題，常有似而不似的作法。此硯利用石體原質，石眼成巨星、小島大千塵世。天然人工巧合。乾隆御詩云：「周刻虞章意創新、幾曾上古有龍賓、眼中卻合堯夫句、三十六宮都是春。」乾隆代表一部分後期鑑賞家，對工藝頗好新奇，對書畫文智則不免嫉窄褊退。

傳統中的現代

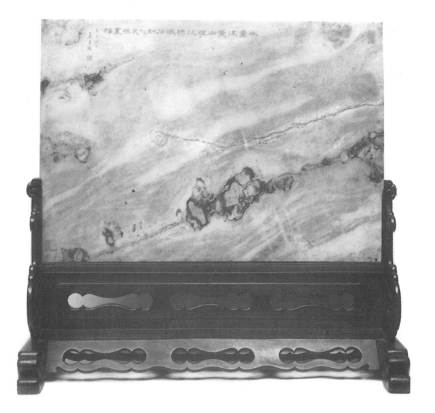

17. NATURAL PATTERN IN MARBLE SLAB.
18th century.

Marble sections, such as this, having natural pictorial patterns, were mounted by connoisseurs in frames or on stands. Juan Yüan, a well-known connoisseur of the later 18th century, owned this stone. His short comment, engraved on it, indicates that it reminded him of the form and color of a mountain and of a brook. However, there is a Chinese poem which expresses the limitations of such an object in these phrases: "Wind relishes coming of butterfly; moon is monotonous when man is gone." Or, as William Blake puts it, "Nature without man is barren." Art without the touch of intellectual effort cannot be art. A chosen object such as this, a nonfigurative design, or, as in contemporary art, the psychological visualization, can be highly controversial. In each there exists a kindred pictorial stimulus.

18. BOILING WAVE.
Painting. Wang Chen. 18th century.

Here is an over-all abstract pattern of waves, particularly interesting as compared with the preceding natural marble design. The texture of the waves with their emotional turbulence resembles the Abstract Expressionist approach.

圖十七　大理石一方
　　　　這種天然畫或因浮紋或因色質、不似而似久爲收藏家眷愛。清阮元題句認爲如山色、如激流是他的見幻。古人愛玉石紋理，未嘗言其所以然；今人以智力求紋色抽象狀況謂之「心理形態」。舊詩有句「蝶來風有致、人去月無聊」。自然無機之物加以人性才有致。無人文便不成爲文藝。觸物生情、委情於質，二者異途而一，象形與否尙在其次，其中美感絕非偶然。

圖十八　清　王宸激流圖
　　　　拍天沸浪，與前大理石紋異途而一。藉激水悚慄，與約紐「抽象印象」派不約而同。

傳統中的現代

71

19. A WAVE UNDER THE MOON.
Painting. Artist unknown. 12th century.

Here an unknown court painter of the 12th century has created a texture of vibrating lines almost in the mood of Max Ernst.

圖十九　宋　無欵洞庭秋月水
平湖滿月、固然富於詩意。有限的線條、是波如理。圓月掛空、天風冷冷、萬念俱灰。馬克士‧昂士，時代畫家，有一圖與此絕似。

The interest in rock formations, as shown by the following plates, goes back to a very early date in China. It is the natural, abstract form that fascinated the collectors. It is recorded that the Han Emperor Wu of the second century B. C. built a garden with rocks resembling islands overseas. Throughout the T'ang and Sung periods there were passionate rock collectors. The painter Mi Fu, of the twelfth century, published the first catalogue of a rock collection. When he saw a fantastic rock, he saluted and addressed it, "Brother!" At about this same period Emperor Hui Ts'ung combed the whole nation to assemble fanciful rocks for one of the most elaborate of formal gardens. Such collectors were interested in the color, substance, and texture of stone, but were most fascinated by the rock formations. They were possessed by a love of "form for form's sake."

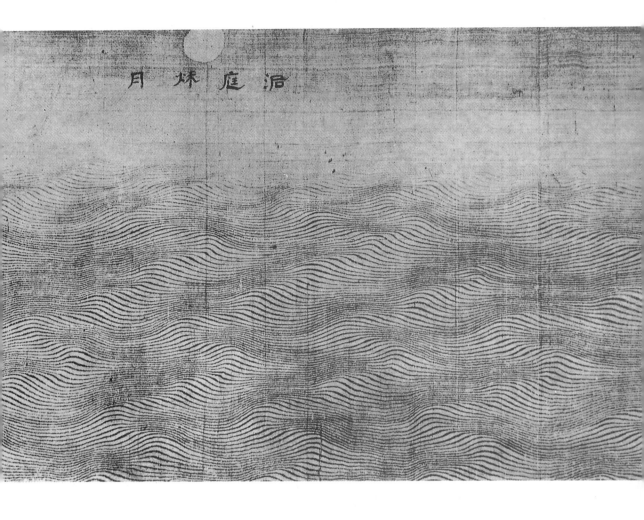

洞庭烊月

以上諸例是取畫面的韻節極明顯的。利用重疊返復的音樂法、起動如呼吸、伸縮彷彿脈搏。細察宋、元諸大山水家的皴法，各有各的節韻。此間「目中」意味如舌嘗、手撫，是直覺的「觸」感。

傳統中的現代

73

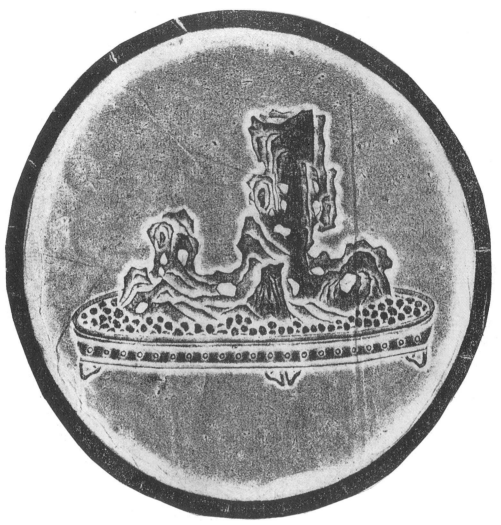

20. NATURAL ROCK FORMATION ON SMALL PEBBLES IN A CERAMIC CONTAINER.

Wood carving. Artist unknown. 16th century.

This type of arrangement was created as a table decoration.

圖二十　明　墨丸搨片

中國愛石之癖起端悠久。《史記》載漢武帝造建章宮便開築磯石，做三山仙島景飾。唐庭園史自不待言。至於宋，米芾拜石兄、撰石譜、徽宗建「艮嶽」舉勸國之動、集奇石之大成，是達愛石的極點，其後石記石譜不勝枚舉。這種石癖是爲其理質、爲其形狀詭奇，並不追究像什麼，純粹「形」的嗜好。此圖示一俊石坐小石子上瓷盆承之，清供案上，是純造形之崇拜。

21. A FUNGUS.

Painting. Chu Ta. 17th century.

This is a casual form closely related to those of the rocks. The natural phenomenon is the given form, but the artist invested it with a soul.

圖二十一　明　朱耷蕈圖
　　　　仙家靈芝，其形怪異與石
　　　　相等。是蕈草果眞如意、
　　　　還是人取其如意?

22. ONE OF THE ROCKS ILLUSTRATED IN SHIH CHU CHAI.

Wood cut. Artist unknown. 17th century.

This rock is mounted on a wooden stand as are contemporary sculptures. The well-known Tai-hu rocks were, in fact, artificial, hand-sculptured forms, manufactured since the 11th century.

傳統中的現代

圖二十二　明　十竹齋木刻石譜之一
　　　　以石鑲木座上，洞心弧體，正如一抽象
　　　　雕刻作品。吳縣太湖石全是人造雕石。

75

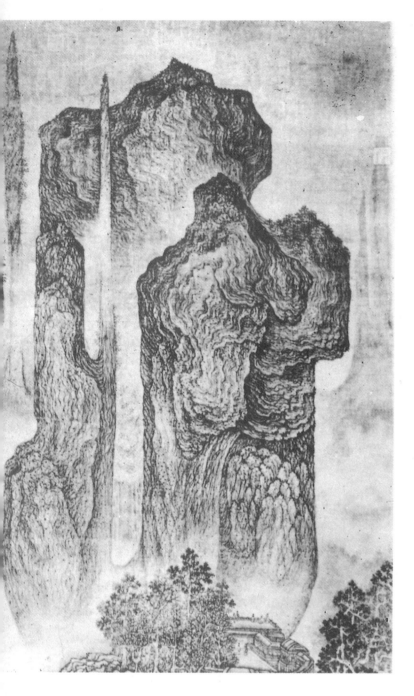

23. MOUNTAIN LANDSCAPE.
Painting. Wu Pin. 16th century.

Here the rock has been enlarged into a mountain, in fully sculptured volume and rich relief. This is an example showing how a landscape subject is handled by some Chiness artists. Nature offers the accidental form; what to make of it is up to the artist. Lyrical interest is only a pretext or point of departure.

圖二十三　明　吳彬山水
　　　　以小變大，磯石成巨巖。
　　　　其凸凹厚薄之狀猶存立體
　　　　軀圍，可見中國山水之取
　　　　材，正在這天就人意任我
　　　　取擇之處。下意識的趨取
　　　　純造形，超過實景詩境的
　　　　掩護。畫面抒情有限、正
　　　　理無窮。

24. MOUNTAIN LANDSCAPE.

Painting. Shin T'ao. 17th century.

Is the subject large or small, rock or mountain? Reality or imagination — what does it matter? Ku Ning-yüan of the 16th century said, "Take any dry wood, dull stone, a pitcher of water—a desolate, barren forest, totally remote from man. Yet, with profound emotion and a rigid, objective eye, the artist may probe where the deepest meaning lies and a painting is born."

圖二十四　清　石濤海山圖
　　　　　與一塊岩石相似、是小是大、
　　　　　是眞是幻。明顧凝遠云:「或
　　　　　枯槎頑石、勺水疎林,如造物
　　　　　所棄置,與人裝點絕殊,深情
　　　　　冷眼求其幽意之所在,而畫之
　　　　　生意出焉。」

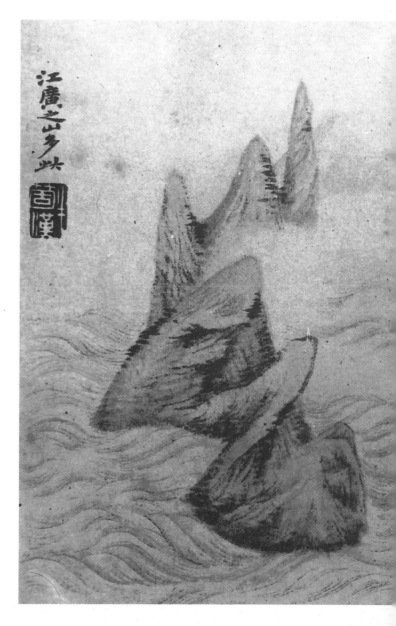

傳統中的現代

25. MOUNTAIN LANDSCAPE.

Painting. Shih T'ao. 17th century.

The mountains have a certain cubistic quality. Their crystal peaks are about to fly away. If one insists on the reality of the scene he may "chew only dregs." The artist has recorded a familiar image happening within himself.

圖二十五　清　石濤山水
硬指此景爲寫眞、則嚼其糟矣。重複王微句：「以寸管之筆、擬太虛之體、以判軀之狀、畫寸眸之明……。」軀體之狀不一，付與靈魂才能生動。

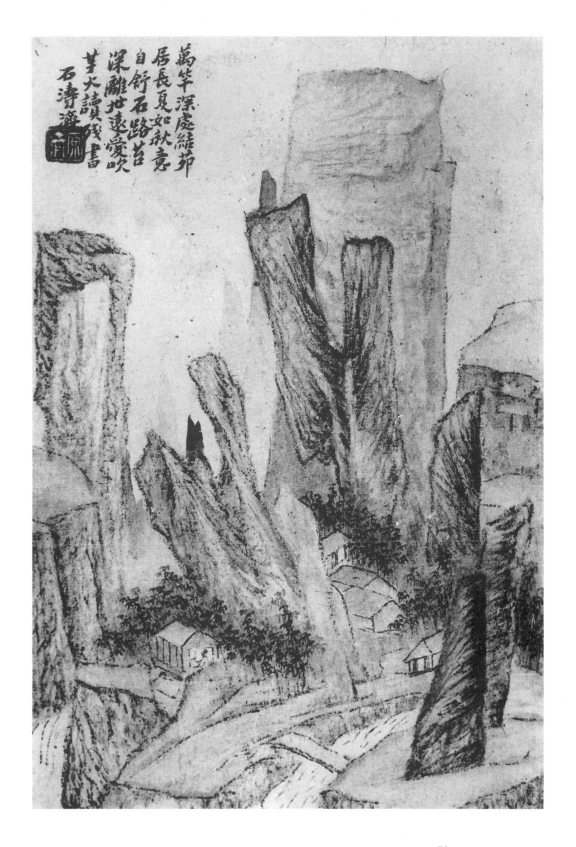

萬竿深處結茆
居長夏如秋意
自衝石路苔
深離世遠愛吹
葦火讀殘書
石濤濟

79

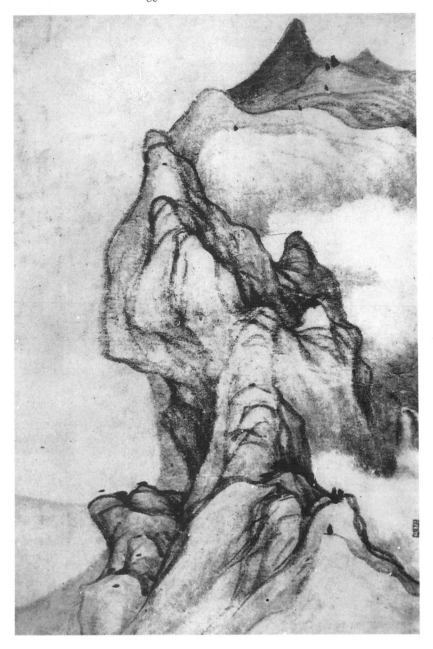

26. MOUNTAIN LANDSCAPE.

Painting. Kung Hsien. 17th century.

The plastic volume here dissolves as though into steaming clouds. There is constant motion throughout the painting. As Huang Yüeh said, "Like melody lingering on string; like fog fading into mist. ... The apparent, large or small, becomes intangible, fluid."

圖二十六　山石積體在清龔賢此幅中便「體物週流」如行雲。黃鉞謂之「如音棲絃、如煙成靄」。

27. MOUNTAIN LANDSCAPE.

Painting. Mei Ch'ing. 17th century.

The dominating force of this sweeping mountain landscape has an
immediate impact.

圖二十七　清　梅清作

此幅長巒如揮。偌長畫史只成就趙松雪鵲華秋色及此二幅荷
葉皴。其中意趣是芥子園畫譜所不敢言論者。

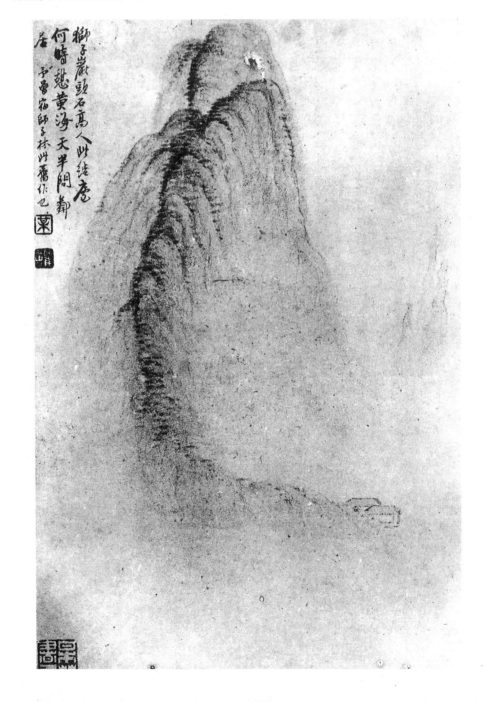

傳統中的現代

The landscape examples shown in the preceding plates (23-27) demonstrate what line really means in Chinese painting. Such work is not created according to rules or to types of brushwork. The subject is handled with full freedom and off-hand ease. Earlier, in the ninth century, Chang Yen-yüan said, "One should revolve one's thoughts and wield one's brush without consciousness of the act of painting. No halting hand, no freezing of mind, and the painting, without his realizing how, becomes so."

Similary, Baudelaire demanded that, "the commands of the mind may never be distorted by the hesitation of the hand." For those who believe in speed of execution to avoid hesitation of the mind, this is the valid viewpoint; others may achieve more by working in an attentive, slow, and even delicate manner. The nature of man covers wide ranges of talents and abilities. Power exploding has obvious force, but contained power has strength, too.

以上諸作品並不代表其作者平生作風，即使偶得之便是難能可貴。這便是明季以來斥卑職業化作品的主因。須知此類作品，甚至任何畫家傑作，各有其單獨的絕境，只可有一，不可為二，一倣便成屍體。唐張彥遠云：「運思揮毫、不滯於手、不凝於心、不知然而然。」法國詩人波得烈說：「然則心之指揮不曲委於手之措滯。」有人取此又認為作畫應以急捷為上，唯大筆方才「寫意」，而生警悟。腕無停留則靈無阻礙。以上各組作品證明：神趣至處意出畫外、手法精時隨心所之。在乎達與不達、不在速緩粗細。「向內」者取平淡、「向外」者多險奇。一絲之勁可敵萬夫。「力」的表現應有種種方式。

傳統中的現代

傳統中的現代

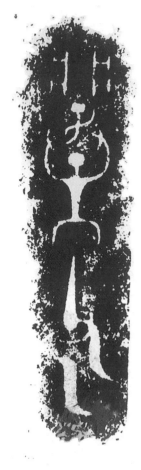

28. SHANG BRONZE INSCRIPTION.
Artist unknown. Ca. 12th century B.C.

Here we have a simple pictograph showing an obvious sense of design.

圖二十八　商　鐘鼎文

象形文字減筆刪體始終與圖未脫離關係。此記、字形大小、線條闊細、啟示作家心。章法尤可喜。

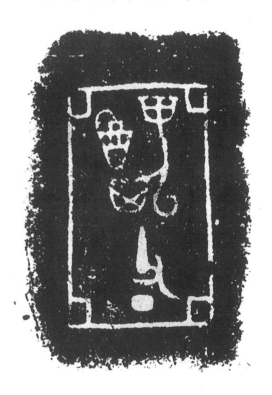

29. SHANG BRONZE INSCRIPTION.
Artist unknown. Ca. 12th century B.C.

This example is arranged within a rectangular enclosure. The origin of the word "painting" in Chinese may be of interest here. A field is shown 田 within its limits 囯. At the top a hand ⺕, holding a brush ⺉, 聿, on a limited area 畫, 畫, thus completing the concept. It is interesting to note that the principle of the "enclosure" was already in existence in this early period.

圖二十九　商　鐘鼎文

四邊加欄、限界之始。畫家從田、從界口。以手⺕持⺉於一有限之區域而成畫。

30. PICTOGRAPH DESIGN FROM HAN TILE.

Artist unknown. 1st century B.C. or A.D.

In this example the character "home" is composed with other elements into a design.

 From Shang to Han, Chinese characters passed through numerous changes and were eventually developed into nonfigurative or abstract symbols. Handwritten characters immediately evolved into the art of calligraphy and were then much used in handicraft designs. These characters returned once more to the pictorial, decorative sphere, as with the example here.

傳統中的現代

圖三十　漢　瓦當殘片
　　　　文字由象形歷篆籀，發達至全符號的楷書、草書。秦、漢磚、
　　　　瓦、鏡、鐘等工藝也採文字作圖案。六藝之一的文字書法堅持
　　　　圖畫作用。

傳統中的現代

31. HAN SEAL DESIGN.
Artist unknown. End of 1st century.

Seal-making in China, after serving its functional purpose, also developed into an art in its own right. This was a development similar to that of the ancient Greek cameo seals or that of the seals of the Indus civilization, with complex linear designs arranged to fit into a small, twodimensional area. From Han down to Yüan, numerous fascinating seals by unknown artists still survive.

圖三十一　漢印

印章也是字記分支。兼書畫之長。布局無立體遠近之分陳鋪面上、陰陽虛實以經營位置爲主。秦漢以來有無數奇妙之作。

32. HAN SEAL DESIGN.

Artist unknows. 1st century.

This example shows exquisite spacing and abstract design. From the 14th century (the Yüan Dynasty) on, painters practised the art of seal-making. By the 16th century seal-carving had come to be a highly regarded form of individual craftsmanship. Thereafter, painting, calligraphy, and the art of seal-making became closely related for many artists of the literary school.

圖三十二　漢印

　　畫家自趙孟頫始兼工金石學。併篆刻爲修養之一。及至文衡山、文三橋父子其風大盛。印章自此供書畫許多巧妙結構。與宋之「三遠」位置不同。

33. MODERN SEAL DESIGN.

Artist unknown. 20th century.

In this and in the two following seals (Plates 34-35) we find designs built up of broad and thin lines, stressing both positive and negative configurations, with slanting or cursive elements, all mutually interadjusted into a highly sensitive conformation. They show an exquisite sense of contrast and of spacing.

圖三十三　近人印章三方（之一）

　　刀筆頓鉏稀密、無絲毫不謹。一橫一豎。

傳統中的現代

34. MODERN SEAL DESIGN.
Artist unknown. 20th century.

圖三十四　近人印章三方（之二）
　　　　或傾或屈、不僅線條粗細斷
　　　　連有關、空白邊界俱是章法。

35. MODERN SEAL DESIGN.
Artist unknown. 20th century.

圖三十五　近人印章三方（之三）
　　　　所謂「尺寸之制、陰陽之數」。
　　　　如此聚精會神、如何不啟發
　　　　心思。

36. CALLIGRAPHY.

I Ping-shou. 18th century.

Monumentality does not depend on size. Still, it is interesting to examine this example written by the 18th-century seal artist. Here we find a new approach to measuring and spacing within an enclosed area, which was further developed in later painting.

圖三十六　印章是小型、變化方寸之中，雖則藝術偉壯感不在乎面積大小。清、伊秉綬此書一尺以上，全是印法。

傳統中的現代

89

傳統中的現代

37. CALLIGRAPHY IN ANCIENT STYLE.
Chang T'ing-chi. 19th century.

Here is an excellent example of pictorial
penmanship. Construction and spatial
relationships are more liberally treated in
handwritten calligraphy than in that of the
seals.

圖三十七　清　張廷濟古籀
　　　　　書法格局邊限不似印章緊湊。
　　　　　然而書畫用筆兩相璋益自不待
　　　　　言。

38. A TRAY FULL OF CHERRIES.

Painting. Ch'i Po-shih. 20th century.

Ch'i Po-shih was also a great seal artist. Here he shows clearly how much he was influenced by the seal scripts with their control and dynamic sense of design.

圖三十八　近人齊白石篆刻特長，因此其畫布局精簡用筆準奪、爲世人所仰。此圖全用篆籀筆、與前頁同。櫻桃盆架在畫中的地位是印章的修養。

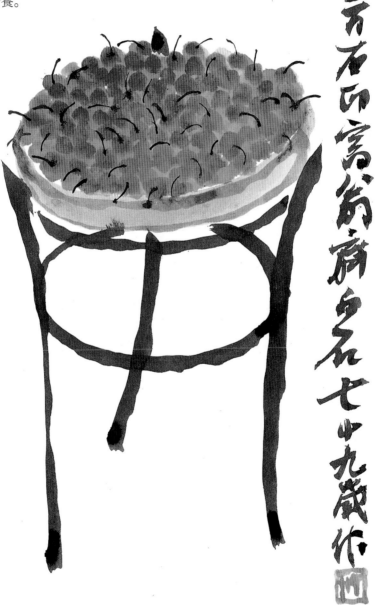

傳統中的現代

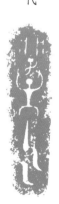

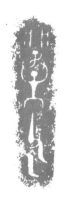

傳統中的現代

39. DRAGON. CALLIGRAPHY DESIGN.
Teng Shih-ju. Late 18th century.

Now we arrive at the direct relationship between calligraphy and painting. The word here is "dragon." Almost a dragon itself, the graph was swiftly executed with the impact of lightning. This and the following examples (Plates 39-46) are done by the rapid methed.

圖三十九　清　鄧石如書

　　提起書法與畫法的關係，此後所舉之例都是書畫相往返的作品。多為簡捷速描。此龍字減筆恰如曲龍。

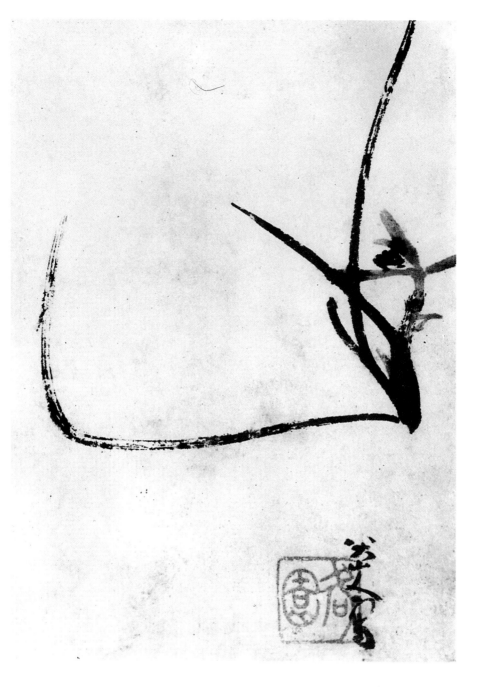

40. ORCHID.

Painting. Chu Ta. 18th century.

The artist has chosen to show his orchid symbolically, as a graph. He has condensed it to such a degree that it comes close to the original pictograph creation.

圖四十　明　朱耷蘭草

　　彷彿草書一字。當初上古創文字時，縮體減形與此僅一線之差。
彼爲記文達義的符號、此爲藝術達意的象徵。

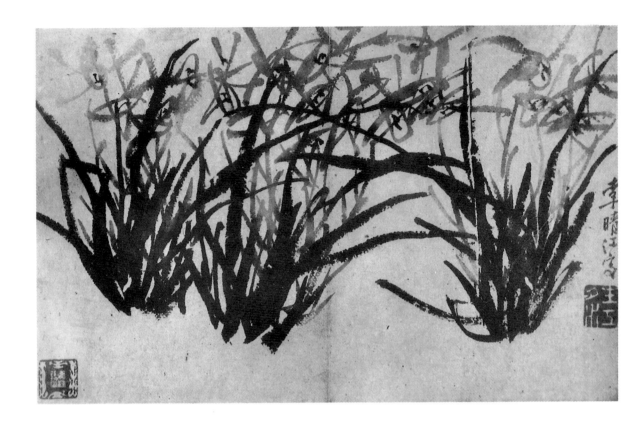

41. ORCHIDS.

Painting. Li Shan. 18th century.

Li Shan was also a seal artist. This painting, although it represents
orchids, really shares its formal ideals with Hans Hartung. Paul Klee
says, "A tendency towards the abstract belongs to the essence of linear
expression, hence graphic imagery by its very nature is of great
precision. The purer the artist's work (i.e.: the more he stresses the
formal elements on which linear expression is based) the less
well-equipped is he for the realistic rendering of visible things."

圖四十一　清　李鱓墨蘭
中國蘭竹墨戲純是書法。保羅·克利說：「抽象畫的趨使、是
由線條引發。因之以書法描形象者、自然而然便傾向標準化、
理想化。必勝於中肯節要。畫家作品愈純者（就是筆線表現
愈型典者）其作品愈缺於描寫皮毛外形之像」。多少新畫家
在求中肯撮要的能力。

42. BAMBOO.

Painting. Cheng Hsüeh. 18th century.

This painting, by another seal artist, is a bamboo to some, to others simply a pattern of superimposed strokes revealing an amazing fusion of intricate sensitiveness and strength. Here, the difference between a painting and a mute pattern lies in the living, psychic energy.

圖四十二　清　鄭燮竹

　　板橋也是篆刻名手。此圖全是平面布置。順手點來亂而有序。胸中逸氣風韻勃發、與花布所印的不同、是「有機物」與「無機物」之別。

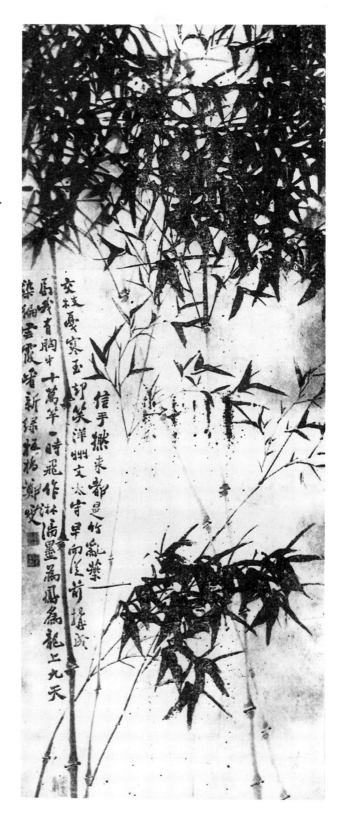

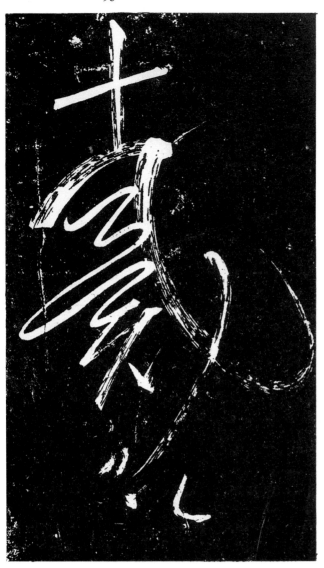

43. ENGRAVED SCRIPT.
Rubbing. Huai Su.11th century.

The rubbing technique is used to obtain "white writing" such as this. Huai Su, a Buddhist priest, was called the "saint" of this "wildly cursive script," which represents the climax of its style. Here we find something in common with the "action painting" of today.

圖四十三　唐　草聖僧懷素拓本之一
　　　　　黑地白文的搨片頗爲今代
　　　　　畫家所採用。癲草絕筆、
　　　　　風馳電閃、魄力呈顯。以
　　　　　豪放爲主。

44. GRAPES.

Painting. Hsü Wei. 16th century.

The artist here shows a dashing spirit close to the modern "tachists".
A contemporary art critic, commenting on a similar painting, said,
"He achieved such a degree of freedom that he could afford to obey
his impulse." Huang Yüeh called this quality "splashing-dripping."

圖四十四　明　徐渭葡萄
　　　　縱橫淋漓、放誕之勢不可了。這種潑辣畫風行今時。有批評
　　　　家說俏語：「他自由到順從感情的衝動」。

45. LOTUS.
Painting. Hsü Wei. 16th century.

Huang Yüeh attributes to such painting "sweeping swiftness." It must
be repeated here, "Rules may cause decadence; unbound by method is
best. Beyond thought, power speeds unchained. A saying tells us,
'Brush is plowing'; now a brush is in sweep. Pours forth heaven and
earth, ancient and new. Dare freely from lightness of heart, nothing
held back. The command from within is not recklessness of accident."

圖四十五　徐渭荷花
　　　　過去詩人騷客性情不羈、放浪形骸、借酒肆情、以文藝洩幽
　　　　憤。破墨潑墨尤勝表現劇烈。然而與禪家減筆頓悟之洒脫不
　　　　同。

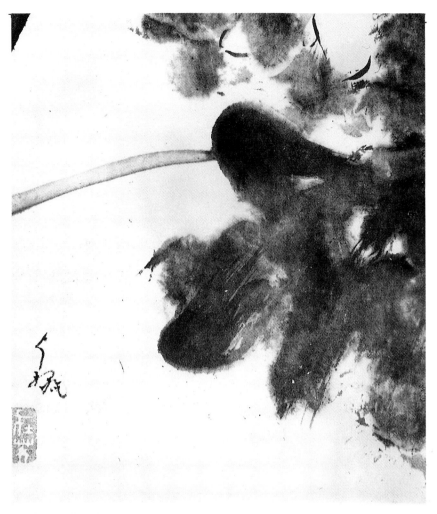

46. LOTUS.

Painting. Chu Ta. 18th century.

Outbursts of emotion in art are the privilege of the times. Today we may be set free by psychiatry. In the old days, poets and artists liked to drink. In such works of bursting emotion, violence, turbulence, and abruptness become the instrumentality used to express force and power. In the case of Van Gogh, schizophrenia may have set free dormant forces of both vision and brush, as suggested by Karl Jaspers. In China, both Hsü Wei and Chu Ta seem to have been victims of the same mental affliction, perhaps to the advantage of their work. Their interpretations, therefore, are far different from those produced through an intellectual drive.

圖四十六　明　朱耷荷花

　　二十世紀心理以任情洩發爲上，於是文藝有以暴強顯示者。在西洋有范荷（梵谷）開創狂熱畫風，他本人不僅天才，確有神經失常之症。偏巧徐渭朱耷二畫家也有失常病狀，與後期揚州八怪虐浪笑傲者又不同。情感抑壓難舒，奔放於其作品，毅力天才相標榜，全無造作，性情必須眞摯懇切。

傳統中的現代

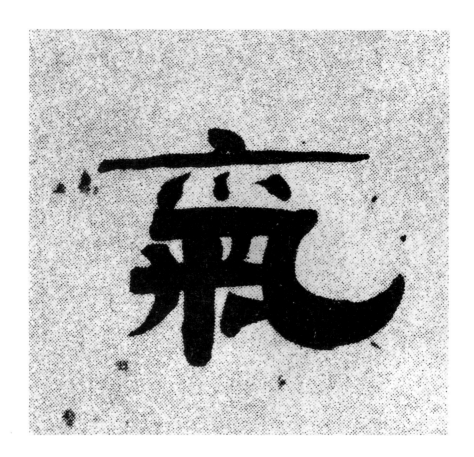

47. CALLIGRAPHY DESIGN.

Artist unknown. 19th century.

Chao Meng-fu, 13th century, once asked his fellow painter, Ch'ien
Hsüan, "What is the climax of literary painting?" Ch'ien Hsüan
replied, "It should be like that of Li-shu." Li-shu exemplifies the
chancery school of calligraphy, characterized by a firm, balanced style.
Its simple, concentrated appearance is both strong and profound.

圖四十七　趙孟頫問錢選：「可謂士氣?」錢答曰：「隸體耳」。恭肅端整、
　　　　　穩而全、篤而厚、似乎傾向中庸道德觀。爲中國畫之特色、
　　　　　與前數例有別。

48. LANDSCAPE.
Painting. Lü Ch'ien.
17th century.

There are many paintings replete with the Li-shu atmosphere but perhaps this example will suffice to illustrate the quality. The rocks here are like a pile of apples, as in a still life. The painting deals with a state of mind, objective, above petty emotion. It has almost an ethical over-tone, the philosophic conception so typically Chinese. Yet this approach is to be found in much the same degree in the work of certain Bauhaus masters, or of Hans Arp. It is the quality Huang Yüeh called "all wholesomeness."

圖四十八　清　呂半隱山水全是隸體作風。宋、元、董巨一系諸大家多少載有「隸體」品格。山水布置如靜物擺設。是一種超越客觀態度。七情六慾如靜如枯、其實這種境界如漢斯阿伯「包豪士」一派幾何藝術家、利用物理科學、講理性邏輯因素、其鎮重處與隸書「氣」字同 (圖 47)。黃鉞以玄理括之:「萬象遠視、遇方成圓。……圓斯氣裕、渾則神全」。

傳統中的現代

49. TIGER.

Calligraphy. Liu Yung-fu. 18th century.

Here is revealed a unique blend of image and the abstract. It is a cosmic symbol endowed with an evocative physiognomy in its own right, monumental and free of self-conscious pathos.

圖四十九　清劉永福書　大虎字
雙目瞳瞳雄如生虎在座。是文智摛住渾沌原力、是人文也不甚分析、超脫自矜自憐、彷彿原始之結繩、至壯至簡、藉爲書尾鎮、而畫理則淵淵無窮。

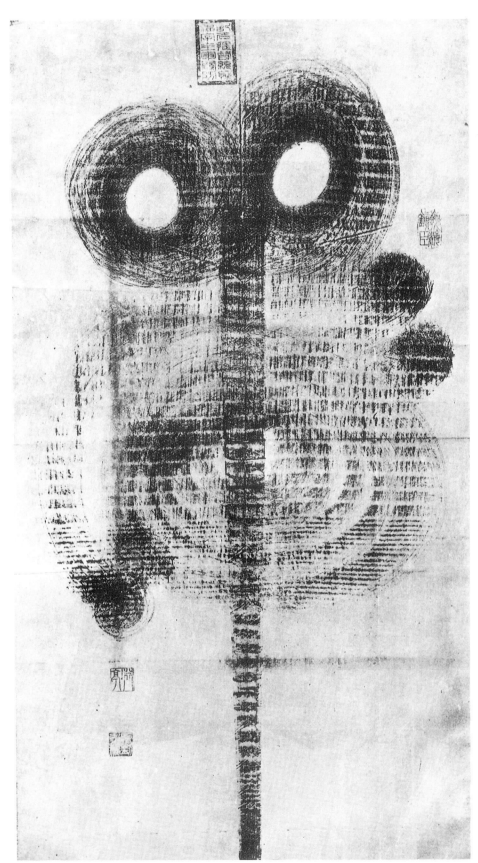

傳統中的現代

下卷

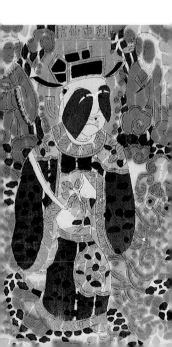

新版序言

　　《中國畫選新語》於一九六三年初版，是根據我一九五七年的講稿寫成。當時，我已在檀島定居八年。五七年與外子艾克①初次周遊歐洲，共十七個月。遍覽古蹟名勝，參觀公私藝術收藏，所經之處與西洋學者同好談笑風生，暢論古今。最後我又單獨留在巴黎五個月，籌備個展，結識許多藝文界人士。當時我年紀尚輕，法語僅可會話。初見世面，稚怯覷覦。在向歐洲與許多名人請敎時，覺得他們全無凌人之態，與我平等議論，方才感覺到自己已步入成年，心中充滿激動之情。書中內容泰半爲我平常爲國外大衆講解中國美術固有之優越，精品不論古今，都合世界標準。中國有悠久的文化，聰慧的本能，多種的智識，在文藝上，一向追求超越時代，爲追求永恆的眞理而努力。

　　孩童時在蘇州外祖母膝下，啟蒙刺繡，塗描書畫。及長，專修美術，時有急進之渴望，只知繪畫是要與古人一較上下。一九三七年北平被日本占領八年，兵荒馬亂之際，親見國破家亡。事變時，我剛滿十三歲。在市上買到一把匕首，帶在身邊，

傳
統
中
的
現
代

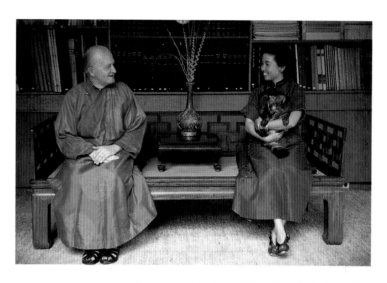

圖 1　1969年曾佑和與艾克在家中同影

預備隨時面對敵人，以一命相拼，而滿腔熱血無處可施。隨後
患肋膜炎，大病一場，閉戶臥牀六個月，兩年在家中補習。四
〇年，我考入輔仁大學女校美術系，持筆學畫，如赴戰場，誓
以全副心身，要爲挫傷的國家文化有所建樹。後來結婚出國，
更加集中心力創作，希望能在世界立足，瞬息之間已年入古稀，
就是距此書初版，也已有三十餘年。雖身經滄海，但一生未懈，
原志未消。午夜夢迴，常自問如今我的思想有無進步？有何心
得？是爲續篇之作的主旨。

　　承羅靑先生推薦及劉振強先生美意，接收再版一九六二年
的《中國畫選新語》小册爲「藝術特輯」之一。又邀加續篇及
圖片。在此附加的第二篇，內容並不連續論古人，是敍述我個
人研究畫學的經過，完全是一己之見。但一生浸漬在東西藝術
之主流當中，又在高等學府美術系任敎，從未以藝術爲遊戲悅

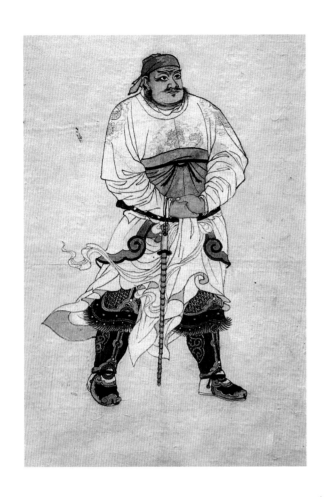

圖2　張飛
　　曾佑和　1942　豎英寸11　橫8
37至38年，與同鄉老師學畫。完
全學徒方式。將畫稿放「考備」
紙上白描人物。兩年只畫工筆人
物，不許寫意。38年溥忻(雪齋)
老師見後嗤曰：俗不可耐！遂
放棄人物。從雪齋雪窗（佺）畫
山水。但白描功夫造成我耐心細
寫的習慣。

圖3　三馬圖局部
　　曾佑和　1950　豎英寸21¼
橫18½
兩位溥老師都畫趙子昂派俊馬。
在檀島初來時租屋僅一間，一張
桌上吃飯、寫信、畫畫，都是它。
這幅是回想老師作風。

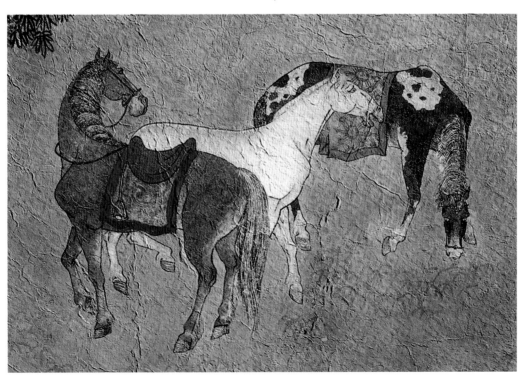

文房諸寶戴文震亨
長物志真硯田筆
耕也
淳多爲戲耳

圖4　文房四寶局部
曾佑和　紙本水墨　1972　兩幅手卷　每幅豎英寸$10\frac{3}{4}$
長13英尺
在此時，已築家有畫室。回憶北平書案上的筆墨紙硯。錄文
震亨的長物志。

己自足，也未借題諷刺世事以洩憤。一生經驗戰前，抗戰期間，
及戰後昇平等多重人世心理的變化，從未敢虛度光陰，四處享
樂，純以學術態度研究美學。時光荏苒，越一甲子，在此表數
語，求教於大雅。《論語》有句云：

　「七十而從心所欲不踰矩。」

希望是老馬識途，經驗之談。以此自況，實因心有所感，而決
非自滿。

　　　　　　　　　　　　　檀香山曾佑和一九九五

新版導言:
中國畫選新語續篇

二十世紀美術世界之重大變化,起源於社會政府的出現,教育的發達及改革。西洋在十八世紀時,法國大革命出,一馬領先。美國隨後建立第一個民主國,歐洲各國亦陸續改政。過去支配美術的權威如帝王、貴族及宗教等,因其經濟勢力衰落而消滅。藝術家走上各自獨立謀生的道路。及至二十世紀,歐洲出現幾個凶霸的政黨,改革社會,走向極端,迫害教育及思想。於是蘇聯、德、奧各國的文藝思想家紛紛出走他鄉,追求自由。同時因為工業發展,交通便利,彼此相互切磋、研討,使歐美的自由學術大步銳進。在思想上,心理學及精神分析學大盛。藝術也追求「心」、「性」、「理」及「非理性」的衡量,探討人類內在的「意識」、「潛意識」及「無意識」的領域。文藝因此走入「內向」的形上學。繪畫也由印象派而超現實,由象徵派而入抽象畫。

英國學者赫伯瑞德在一九六四年時,評論十九、二十世紀

傳統中的現代

傳統中的現代

西洋美術變化之大，原因有二：一是藝術思想交流，二是接受異國文化(Exotic Cultural)。所謂的異國，是指希臘、羅馬、歐洲宗教貴族藝術傳統之外的「影響」，其源有七：

一、東方文化（印度、中國、日本）。

二、非洲及太平洋土著藝術。

三、樸拙之民間、素人及兒童作品。

四、史前新石器時代的作品。

五、白人未入境以前，南美土著藝術（墨西哥、祕魯等）。②

六、紀元前上古希臘及伊屈斯根(Etruscan)文化。

七、天主教初期、紀元一至五世紀時的古拙作品。

試以二十世紀前半期的畢卡索(P. Picasso, 1881-1973)爲例。他最會吸取別人的成就，順手拈來，任意迭變、氣派爽直，別人精華入手便成爲他的特色。畢卡索不喜讀書，不求甚解，因此解釋他藝術的書籍比一般畫家多，市場上靠他盈利的也多，效倣他的畫風及爲人的更多。

克利(P. Klee, 1879-1940)與畢卡索同時。他在包浩斯美術研究院授課(Bauhous)，一生只創作試探性小品，生前出售極少，也不如同校教師出名。然克利的變化更多，但他不賣弄自己。克氏擅用科學邏輯分析，綜合人性與畫面的感應，探索線條、色彩、形象如何可以呈露內心。以心智推動畫筆，如在意識及無意識之間。他的圖案簡易，但寓意深遠，這都是出自他鑽研後所獲的心得，十足的「文人」性格。他的學識高深透達，教

法有條有理③，至今仍爲一般美術學院所樂於採用。他小畢卡索二十歲，但對後代的影響更大。畫家跟隨畢卡索，則容易借用取巧，跟隨克利則能探畫法之因，見藝術之果，自有伸展的餘地。

二十世紀的民主政府及富商，肩負大衆教育之責。以美國經濟力之富強，蒐集歐洲各系思想藝術，包羅廣泛，我們從巨型私立美術館林立之事實，便可看出。戰後世界繁榮，藝術市場蓬勃而起。於是畫廊、拍賣蜂湧而出，鼓吹宣傳藝術家，如捧舞臺明星。代理人挾半斤八兩的業餘學識，翻譯玄妙，爲奇奧的作品，大做解釋，提高身價，造成空前未有的藝術喧嘩市場。爲了出人頭地，藝術家也強調驚奇非凡，造成二十世紀後半期的各等藝品氾濫。

嚴格的觀察，二十世紀前半期，西洋文藝確實傑才輩出。突破舊習，思想澎湃，融合東西。及至二十世紀後半期，科學工業發展速度加快。報紙、雜誌、書籍出版難以計數。電視、電腦資訊發達，新聞傳播，分秒間遞至九洲大城，改變了家庭教育及個人生活。同時工商業的競爭也逐日繁增，宣傳有術的可以盛誇其言，再加上民主社會的官員，一般都是向民衆甜言諂媚，誇張片面，社會上充滿了以求速成，充滿了不誠實的誘引及炫人耳目的招搖。藝術家也尾隨群衆，投機造勢，只求眼前的利益。取材如報紙雜誌，則偏重反常的畸事，煽動一般男女，諷刺政府社會，以不負責任的評斷謗毀，嘩衆取寵。急進

傳統中的現代

青年羨慕「石頭」藝人的號召手段④廣播粗暴野獷，以為此乃「自我」表達之特技，以為反抗便是「前衛」。目前的「前衛」藝術，已脫離任何傳統的畫技，完全利用工業廢料，表現「潛意識」「非理性」的行為，物件不僅巨大而且瑣碎，連美術館都無地可置。

青年人氣吞山河不可一世，是人生必經的過程。他們很容易藐視理智，以為推翻一切，便是自由。然一般罪犯，不求自振，專門欺詐殺戮巧取豪得，這也是一種自由的反動。療養病院也鼓勵神經錯亂的患者借繪畫雕塑以洩難言之隱，問題是藝術是洩憤、還是一種比個人洩憤更有意義的行為？設若我們以人性善惡為標竿，那把藝術推立在頹敗非理性之上，豈非不智？

中國傳統藝術之我見

(一)概說

　　每一時代、每一文化、每一個有思想的人，都有一腔不平之氣。在中國，有「竹林七賢」⑤爲典型，而一般文人棄世厭俗，則比比皆是。十七、十八世紀，明遺民畫家八大、石濤、揚州八怪都明顯對政治社會不滿。

圖5　石濤山水冊8頁之1
豎英寸6　橫10¾

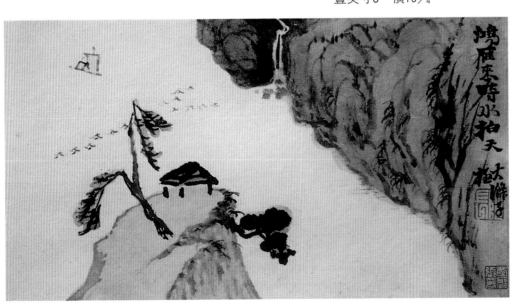

傳統中的現代

圖6　柴丈畫稿上半頁
龔賢　尺寸不詳
題云：「輪廓重勾三四遍則不用
皴矣。即皴也不過一二小積陰處
耳。」

　　十七世紀明代末期，天主敎入華，沿海港口及皇淸內廷開
始接受大批西洋藝術。而許多中國工藝也外銷歐美。西洋大衆
也發現東方美術，追蹤倣模東方工藝，家家戶戶，皆有東方裝
飾。例如日本民間版畫，是爲當時最前進的畫風。

　　及至十九世紀，奸商強霸，開始向弱國用武，四處征服殖
民地，致使國際間種族歧視大增。中國在十九世紀時，政府頹
敗，自身尚未脫離奴隸制度，滿漢階級舊習，四處充斥，腐敗
不堪，朝廷只知排外，不求實際，掩目自欺，妄施愚民政策，
爲保皇衛國之大計，以致中國敎育一敗塗地，至今不振。今日
歐美放棄殖民、鼓吹民主，東亞各國也振興科學工業，東方最
西化的日本，在經濟工業上已有世界領導之地位：行走有汽車

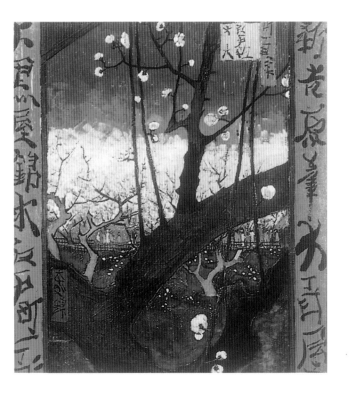

圖 7　A　餐室

莫內Claude Monet, 1840-1926

莫內住宅已是公開紀念館，著者攝於1986年Giverny。宅中牆上都是日本版畫，案上多是中國瓷器，地鋪中國地毯，花園池塘小橋是日本式。

B　日本趣味(梅樹)

梵谷 Vincent Van Gogh, 1797-1858

油畫做日本廣重的版畫。法國印象派，前期後期都喜愛日本屏風版畫及折扇。對歐洲後期的章法透視有極大的影響。

飛機，衣著有裙褲領帶，平日工作，電視電腦，並不覺得有西化之恥。他們在文化教育方面能認清自家優良之處，足以自尊。中國工業今已發展，但藝術尚未脫離古今東西糾纏的苦惱。

　　仔細研究中國藝術史，尤其是近四十年來的文物出土，掘發無數過去書史未載的材料。上古先民，在社會尚未成型以前，便有「自知」之明，創作出登峰造極的藝術。即如玉石之堅，仍能雕修如塑泥。他們有純正的審美眼光，精確的手法及智慧，比起二十世紀牽強附會的抽象藝術，真是強過百倍。當時所作的物件，多為陪葬禮敬出世的靈魂。中國先民相信死後有神靈、生前有超世的宇宙。由此亦可以證明他們對現世多有不滿，希祈魂靈不散，慰藉此生。於是他們便神工鬼斧，昇華物質，創作出驚心動魄的出世絕品。中國中原有本土文化，但每代都有

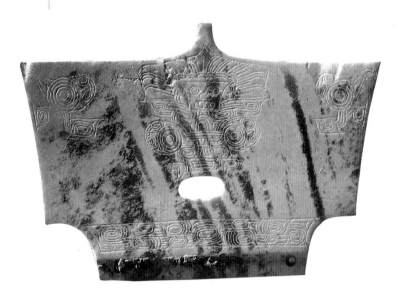

圖 8　良渚玉飾三種　浙江瑤山
A　項飾

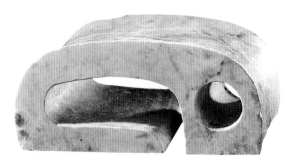

B 帶鈎

C 柄形器

圖9 釋伽度量經
　　十九世紀西藏草稿
　　佛敎典型沿從印度。經中東敦煌
　　或東南亞等地來華。坐立指臂。
　　佛裝等都有比例尺寸定規。菩薩
　　羅漢等主要佛像與中國人完全
　　不同。除唐宋儒家外，佛像爲國
　　人接收。並無嫉視域外的影響。

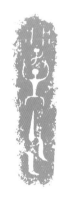

傳
統
中
的
現
代

域外傳入的影響，也遭遇過格格不入的窘態，如佛教雕塑及繪畫，便是例子。但古人能做到適應地區時代的要求。簡單的說來，藝術作到最高之境，便是創作，承傳統的活流而前進。

中國傳統藝術有兩個強而有力的系統，各有盛事。一是所謂的「文人」藝術；另一是「民間」藝術，各有千秋，與歐美不同。中國純正的「文人」藝術是理智的結晶，擁有「自我」的個性。傳統的「自我」近於宗教修養，不可商業化：「成己、成德、成正果」，如剔出其中道德及神話成分，則其精要是文藝智慧的形上學。

圖10　A　柴丈畫稿下半頁
龔賢　尺寸不詳

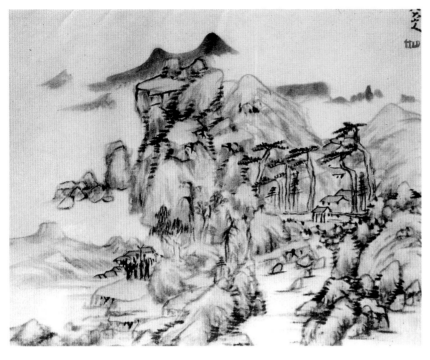

B 八大山水冊8頁之1
朱耷 豎英寸9¼ 橫11
八大的花鳥奇異至今為人模倣。
山水從董其昌文人態度。前後差
錯，坡腳傾斜。半途棄放。樹木
隨處置設。他有黃公望的根據但
無大自然的實情。「自我」之氣盛
強。

發符咒

血君血神中幽君字良弼攝 通流一體敷

圖11 符
民間道教符咒無數，似字非字、
似畫非畫，大都出乎意外，能翻
天覆地。這是道士的創作。可比
今日抽象藝術，符咒可以招神驅
鬼、呼風喚雨。至今年節吉祥字
句祝福祈安仍為一般人的歡迎。

傳統中的現代

傳統中的現代

圖12　民間版畫

　A　天官

手染色

粗魯壯直。卻有馬諦斯Matisse
的風味。

　B　冥衣

剪貼　豎英寸44　橫約42

圖案衣形簡化速寫。鬼神祭祀草
率。但祭送的家人可以安心。

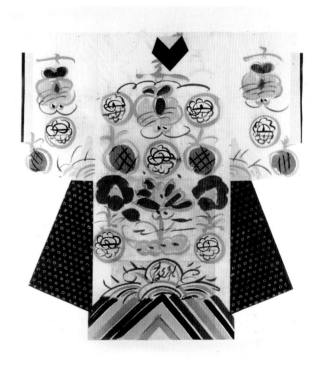

「民間」藝術則本於良知，非文史所能左右。其傳承大半來自口授，與民生共存。最能代表集合民族色彩，富有地方性的民藝是陶瓷：但唐陶不似漢、宋不似唐、明不似宋、清不似明；磁州窯不似吉州窯、定窯不似影青。每一處窯的起端，都是全新的創作，因無個人傳名，便被視為民間工藝。其中貢獻朝廷的，便成了官窯，經過大量生產及模倣，形成群體作風，如此技藝雖保，而個性消失。後代效忠傳統不敢踰越的，只存唐宋皮毛，亦可歸為「民間」作品，代表古時的國粹，不能稱為有「自我」新生的創作。但中國之特色在有寬大的容納性，有能消化能創作的本能，方是正途大道。

(二)自覺

我自識字以來，便持筆作畫。課餘之暇亦無時不畫，一如飲食之不可廢。及至家長認淸我對繪畫的篤切，自十二歲起，按部就班，施以訓練，打下書畫基礎，可謂「科班」出身，在四○年代的北平，受教於舊王孫、名學士之下，模範古人。輔仁美術系在當時是唯一設有廣泛繪畫課程的學校，五花八門，應有盡有。西畫有寫生，圖案由歐美修女教士領導，國畫有山水、花卉、人物、篆刻及東西繪畫史。一九四二年畢業時，遍地戰火，顧生不暇，家庭早已分散，但心中勇氣澎湃，願盡一生以獻文化前程。在京城附近到處寫生，希望能在自然風景中

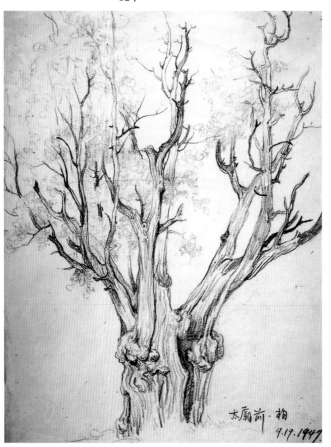

圖13　太廟古柏
　　曾佑和　鉛筆寫生　1947
　　北京城內古樹極多，曲扭蟠結。
　　42至48年間，到處寫生古樹。

圖14　北平郊外寫生冊12幀之1
　　1947　豎英寸8½　橫11
　　附近西山、圓明園是唯有的山
　　景。多平遠村落，一角桑林山麓。

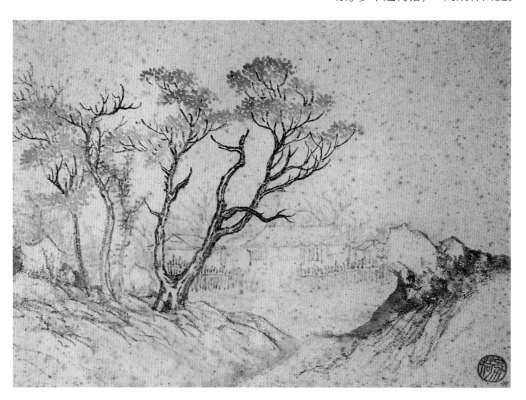

找尋新路。除勤倣古畫原作外，還學裱畫，並替溥佺老師代筆，繼續與啟功老師習詩文考據，又在北大、中央、及輔仁旁聽美術史、經詩等課程。記得在一九四四年十九歲時寫過一首新詩。正適冬季、窗外北風號嘯，搖動黃昏。

「朋友！告訴我！為什麼我的呼吸這樣閉塞？

　好像身背著一個沈重的鐵鍊，

　匍匐在黑黝黝的夾牆裡。

我要擺脫這枷縛，

像東風一樣的狂吼。

　翻轉這冷酷的世界。……

回頭一看，卻發現我身滿血漬，

　倒臥在污泥漿裡。」

　一九四五年結婚，一九四八年輔仁遷校，四九年與外子艾克移居夏威夷。在美國處身西洋美術中心，開放胸懷，觀察各系美術思想，周遊歐美藝術都市，自覺中國基礎穩固，可以跨步前征。由於自己裝裱書畫，發現紙質優良，開始用裱潢技術入畫，提名「綴（掇）畫」。因為畫材入「綜合媒材」，可以參加團體的西洋聯展，頗受好評。安那生（Harvey Arnason）為當代美術權威，認為我的新畫足以自立，介紹紐約的一個名畫廊⑥相識，在一九六〇年與我簽約代理，與美國名畫家如歐奇夫（Georgia O'Keeffe）、斑尚（Ben Shan）、代韋士（Stuart Davis）、馬潤（John Marion）等平起平坐。因訂有契約，果然不斷出售作品，但

傳統中的現代

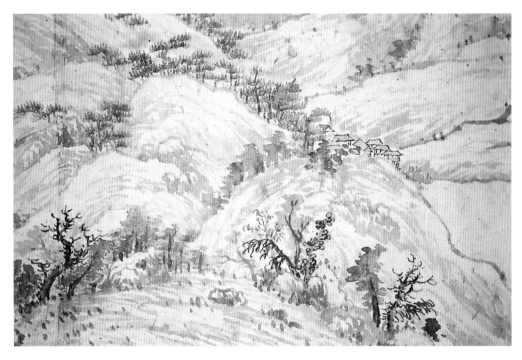

圖15　閩江圖手卷局部
曾佑和　1951　豎英尺1又5寸　長34尺
來檀島五年，未能立家蝸居一室。附近小學校長同情，容我在
下午三時半，學生回家，我可以用教室作畫，室中寬大也有長
案。第一張作品是閩江圖。1948年，在廈門留居一年，得遊閩江
兩日一夜。這是第一次處身大自然的勝景，正適十二月秋色豔
麗，兩岸崇嶺雲霧，回家用鉛筆錄記幾個景色。越三年用黃大癡
筆沒骨色彩作長卷，並賦閩江行。可嘆今日閩江工業化，沿江
污染航髒，不准遊江。

畫件不再屬於我。各地展覽，每年收入可觀，但我與作品及觀
眾隔絕，商業性太重。於是，再次陷入心神不寧之中，如臨懸
崖。我開始警悟，傳統性情不適合市場，遂立意修取學位，重
回學術環境。在紐約兩年，懸梁刺股的苦讀，取得博士學位。
主修東亞美術史，副修西洋現代美術史；畢業任教。蒙哥倫比
亞大學約聘後，在其時，我已飽嘗大都市社會之炎涼，洞悉畫

圖16　A　檀島寫生
曾佑和　鉛筆草稿　1952
B　小草丸石
曾佑和　豎英寸12　橫17
檀島風和日暖，四季皆春。花草
鮮豔。我寫生花卉山水多種。

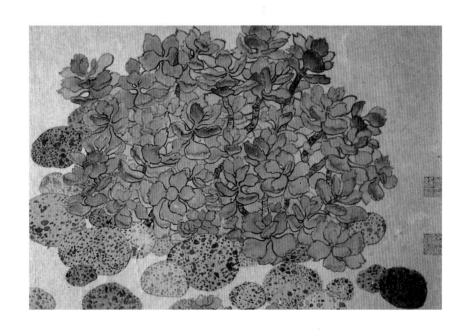

廊商業的內幕，自知捲入無情漩渦，難以自拔。外子艾克身體
日衰，我也體力精神有限，日常必須有靜思默省的空間，還是
隱退靑山碧水的檀香山爲宜。紐約畫廊主人七二年病故，我便
不再約訂畫廊代理，從此不爲他人指使。

圖17　檀島山水小品兩幅　曾佑和

A　沒骨山坡

豎英寸11　橫8½

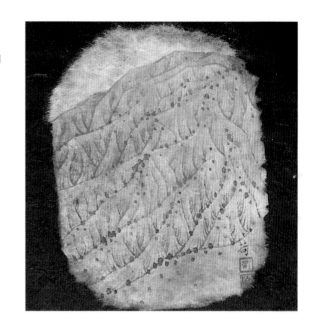

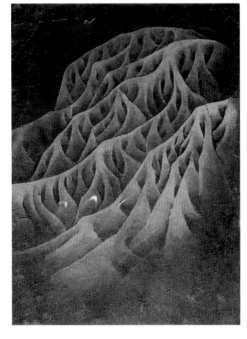

B　石綠山脈

藏青紙　豎英寸8　橫6½

53至56年間，我眼中只見嶇崎的
火山龍脈。畫過大大小小渴筆焦
墨的山巒，意境乾澀。有友人認
為不倫不類。

C　山坡攝影
即使真景。目中只見積
年地質的筋骨。

圖18　曾佑和掇畫
　　以下八幅是較成熟的掇畫。畫廊
　　代理時期。
　A　鉛筆草稿　1957

　　B　檀島日落
　1957　豎英寸43　橫26

　C　林
　1958　豎英寸24　橫48

傳統中的現代

D　高升出界
1962　豎英寸24　橫32

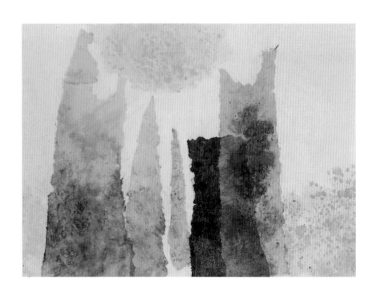

E　漢代古鏡正面

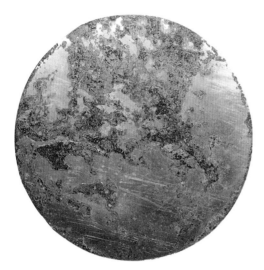

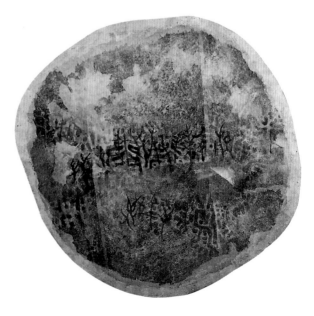

F　上古之鄉
1959
畫此圖時，並未見此鏡。心頭斑
點恰合。

G 拜石
1962 豎英寸36 橫24

H 樹根之歌
1962 豎英寸72 橫48
在此間我用太平洋的樹皮糙紙，
G、H是其中作品。因紙質粗，
不須綴補，可以速成，適合作大
畫。1964年後多用金及錫箔。

艾克於七一年心臟不支去世。我在夏大任聘教授全職、兼美術館中國部主管。講課、行政、考證、整理陳列展覽等，事務繁重，作畫時間大減。但認爲教育是有貢獻的工作，放棄偏好，純以學術客觀審查美術。我在校所授之課，包括全部中國美術史、金石書畫、陶織建築、庭園及各種工藝將近三十年。雖大都是鳥瞰式的概論，但越講越覺得中國的各系美術千變萬化，有哲理可以貫通。果然如石濤所說的「一畫」，但絕不是千篇一律的外貌，懸掛在古人的面目下。中國思想有個堅固的軸心，是層層推出，息息相關的流傳灌溉，絕非停駐在堡壘之中。中國過去藝術中大膽的思想勇氣,比二十世紀的有過之無不及。

圖I9　A　達摩　浙江昭靈寺立石
1409年明初築亭。頑石隱約若人，雖無面目，尊嚴俱在。是中國的抽象。

B　限內之心
曾佑和　掇畫錫箔　1994
此畫並沒有以達摩為範。但脫化
的情意相同。

圖20　明　十竹齋　彩色木版二頁

　A　玲瓏石
　石的喜愛在中國來源極久。或立
在庭院、或置之案頭。離奇狀態
純是抽象的欣賞。

傳統中的現代

B　盤橘　團團靜置
本是無機之物。卻能升「平常」
爲「異常」。

今日大家提倡人權自由，人人能自認聖賢，以「反抗」爲「創
新」，不論是挾古人、或是追前衛，都不過是以五十步笑百步而
已。是古是今、是東是西，如果自身內涵不夠，到頭來空洞的
成分相同。反之，如有思想人智，點滴都是活潑新穎的泉源，
可以不因爲氣性而鬥爭，也可以不被名利驅使。

(三)進展

　　自一九四五年開始，我不斷的講授美術史，審愼發言，對
聽衆有責任心。希望解釋美術創作不是爲「成己」，而是對「人

智」有所會心。直到如今，我自身的盛氣如舊，有時自問：如果我遲生五十年，是不是便會舞筆畫「漩渦怒吼的東風」？作自畫像「身背著重鍊、漬血竭力、倒臥在污泥漿裡」？事實如今我的壯氣比青年時還要倔強，但覺得表面上的自傲不徹底、不夠藝術。經過不斷的努力工作，覺得我已可以擒伏盛氣，將抽象的喜怒哀樂，蛻化成畫中的生命。我所選擇的畫法，點點滴滴都是我經驗的新生。我早在一九四九年出國，畫技成熟，有全權的自由，決定自己的創作方向，四通八達，任我往來。有一個短期間，我幾乎全部抽象。近年來，因不願自絕於傳統淵源，仍重拾景物，把景物簡化到極點，仍能承繼傳統的源流。

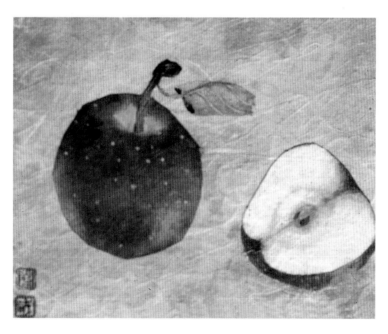

圖21　蘋果
　　曾佑和　掇畫　1977　豎英寸8　橫12
　　掇畫法可通用各種畫體。這是我偶而寫眞的小品。

圖22　曾佑和掇畫

以下四種略示我脫化筆墨的方
向。

A　八大山人　鉛筆草稿

B　掇畫
1958　豎英寸72　橫48

僅略微簡化八大山人，邊框變
化。加以遠近透視章法

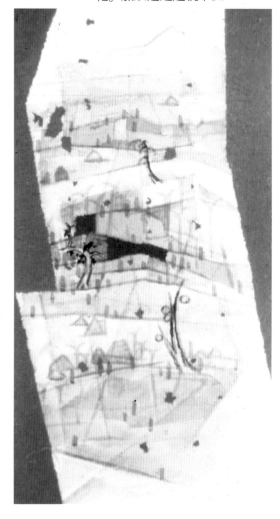

C　深淺明暗
1958　豎英寸48　橫24
連想倪瓚的空間。折帶皴石。

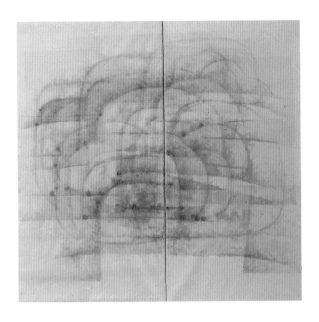

D　奇跡
1991　英寸66四方
連想黃大癡礬石折疊，
比例構合。

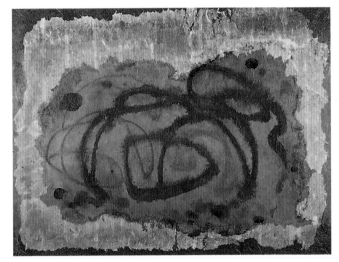

圖23　曾佑和掇畫
　　　以下兩幅是抽象的探試
　　　A　石頭歌舞
　　　1959　豎英寸36　橫40
　　　B　音階之間
　　　1965　豎英寸12　橫48

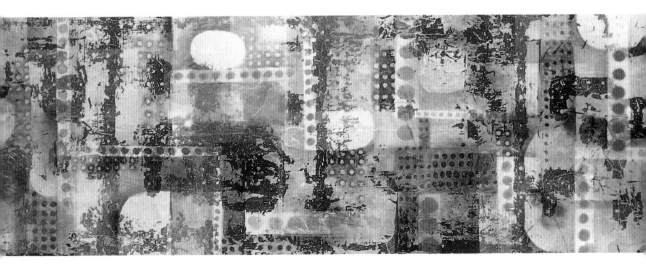

傳統中的現代

C　換面書4頁之2
1991　豎英寸8　橫12

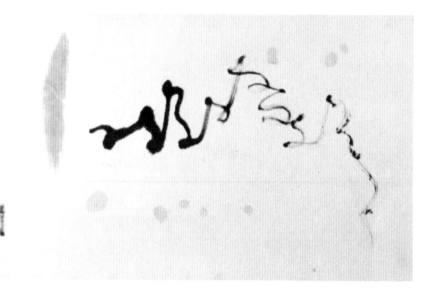

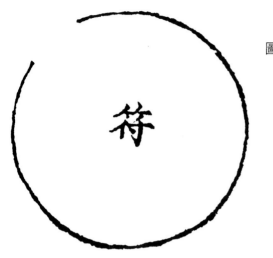

圖24　符　道藏木板
道家以一整圓圈代表太極。有缺口則是符。

中國後期明清的文人山水，早已超脫實景，是爲人性的象徵，布置擺設，在畫中發揮心情動態。古人的潑墨狂草，尤以「動」爲主，急速揮毫，不僅鼓舞中國觀衆，亦鼓舞了西方二十世紀的「行動畫派」⑦。東西兩方的宗教都描寫地獄鬼魔，目的是警世之教育；今世則有惡夢式的「超實派」⑧，轉向譏嘲庸俗，或反映內心之騷動。此外尚有種種新畫派，都爲了要顯示內心，走入如中國古老幾何象徵的「數象學」。中國「內向」的文藝，是將「心情哲學」形式化；西方則是將「人性心理」形式化。

而我的繪畫宇宙觀如下：由於研究史前藝術，講解新石器時代，得知先民放棄游牧生活，開始務農，於是耕耘土地，聚居村落，依靠天時，辨四季節氣，測天文地理，以方圓爲規，日月星辰在上，東西南北在下，反覆周旋，而其死後的信仰，可見於埋葬祀禮。先民對大自然的尊敬化爲幾何形的玉石，也

有人獸交併的代表（商周時代爲主），以禽獸爲主，偶有人形，但大半是謙恭的俘虜。其中亦有山精海怪，不是全能之神。商周已完成供奉祖先之禮，啟發以人爲神、衛護家族的觀念。社會也開始有家族組織，分出階級，國家備制度，斷是非。專賣專利是春秋戰國時的進展，法律規矩是秦漢時的立則。

二十世紀學者多好疑古，作《僞書通考》及《古史辯》。使我們知道如何以今日眼光看清歷史。古典史時常混合迷信卜兆，只可列爲神話傳說。自六〇年代以來，中國考古學識日增，以科學考證闡明眞虛，證明在文字尚未完整之前已有很複雜的思想。古典傳說雖經漢代編輯，但尚餘許多事實可以映照先民敦厚簡樸的思想。他們的藝術創作觀反而純正無比，技術精確，令人佩服，其藝術明顯與當時信仰有關。相對我們今日無神靈的藝術，對他們在作品中所流露的誠切，我們只可羨慕，而追求不得。

到了北宋時期「道學家」將古老的宇宙觀引入象數來分析人們「內在」的「性學」「心學」。在這個時期變通的「易」，組合的「氣」，太極、陰、陽、五行，動、靜、柔、剛等集聚數象學的大成。宋代的道學家避免不了儒家的社會道德觀念，刪修儒家的成見，只求心性，望能「以一心觀萬心，一身觀萬身，一物觀萬物」。又云：

「以物觀物性也。以我觀物情也。性公而明。情偏而暗」⑨

圖25　A　商玉璧

在商周時代表天。

　　B　宋　天文星座

1092木版。考古家認爲先民確實
用璧爲天儀器。

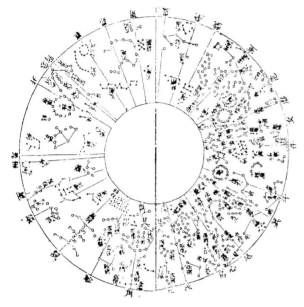

圖26　A　宋　太極圖

木版。北宋時數象學已變化萬
端。並展延用以分析風水、音樂、
醫療等。

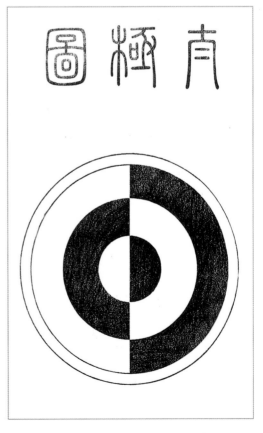

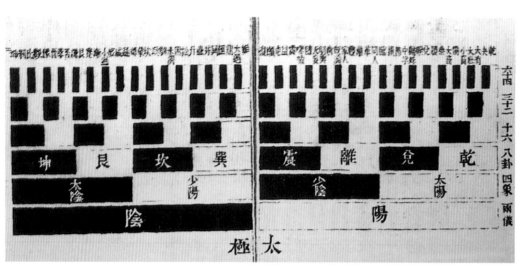

B 宋 伏羲六十四卦

易經複雜的分析不可測量的天命。

C 四季二十四氣節

曾佑和 浮雕造形

1969到1971或收集宋人實用方圓的數象表作成浮雕。代表中國的抽象造形。在傳統的易經信仰範圍內、占卜、風水、先知未來、科學心理迷信混雜。近年來英國李約瑟 Joseph Needham、王鈴、王振鐸等學者，合著巨本中國科學及文化。將古代深奧的科學哲學一一擇出解釋。數象學中有很深奧的造詣值得研究。以幾何抽象講。這都是中國的傳統。

萬物因氣聚而成，氣也有性，氣聚而爲個體的人。以個體的「我」爲「我」，以天下之物與我爲一體則天下無物非我，即以全宇宙爲一「大我」。⑩這是中國的「自我」之略觀。

　　宋儒又說：

　　　　「生之謂性。性即氣。氣即性。生之謂也」⑪
因此畫中有性有氣才有生命。宋儒論世，認爲社會有六分善則治，六分惡則亂；七分善則大治，七分惡則大亂。每一個人的本性之中，都是善惡並存，也因成分可成爲善人惡人。眞理是中立的，不因情而偏。我的創作寧願稟理，可以制我「惡性」的蠢動。因此外在社會的善惡，可以支配「小我」，但不應當搖動那創作性的「大我」。

　　我的本性不喜強橫暴力，屬於食蔬果以爲生的動物。效法駝馬象鹿勤騄的努力，怡情如雁雀鶯鷗，自得其樂，不擾眾生。藝術能化我的好惡爲堅韌，沖霄之量爲畫中之氣。這種心理並不是針對中國文化的煩惱，而是向新世界立個不同的理智。我不取書的線條，以潑墨放筆爲傳統的體質，而走內涵寂感以靜爲動的表達。於是有人認爲我的收斂性情是「女性」特色，這是誤斷中國固有的一種人智，不值一駁。輕視女子，在東西傳統中都有。我本身不覺得女子頭腦有缺陷，也從來沒有參加過任何女權運動。如果今日世界能容納「女子」的思想，也是好事。

　　又有人問我，在國外從事創作，是否因「女子」或「中國

人」遭受歧視？回答是：自然經驗過的。在一九三九年，北平輔仁大學開辦女校時，中國女子極少正式入中學及大學。雖然女畫家在北平相當普遍，但多半是業餘的，距「女紅」不遠。在美國女權比較公平，五〇年代時，一個中國少女，在美術界及丈夫的身邊，不需養家育幼，埋首努力作畫，是非常自然的。不過，美國與中國藝術社會相同，對一個中國女性，總是半信半疑，這也是我爲什麼要努力取得學位的原因之一。在五〇年代，全美國大學只有加州、哈佛兩位來自中國的學者被聘爲正教授。來自中國的女子能在大學聘爲正教授的，我在當時還是領先第一位。在二十世紀後半期，美國社會也生巨大變化，如今夏威夷大學已近有二百位來自中國的教授。在事業上故意謗毀我的人自然有，有本國人、也有美國人；然最難忍受的是來自日僑及日本人。在工作方面，我一直是兢兢業業的。一九六〇年代，我的新綴（掇）畫經過多年研究，能全部開展。自覺有信心，曾歡喜的秉報母親：

> 「我現在已找到我的境界。在這個繪畫環境中，我
> 可以縱情騰躍，能支配我的情感生命。其餘世間的
> 名利計較、爭償瑣事，不會再擾亂我！」

(四)畫法

在國外研究藝術，處身世界古今的大範圍中，視野不再僅

是與中國古人較上下。紙的藝術是中國漢代以來的成就，不僅可裝裱托襯書畫，同時亦兼修版本書籍；在民間工藝中，紙實用的種類非常之多。中國的傳統工藝，一向歸於匠人，不與書畫家並論。近代西洋大師隨時畫陶瓷，製織毯，鑲嵌玻璃，設計雕刻。中國今日已接受工藝為正式創作。藝術家只要有藝術的見識及手腕，可以把一塊頑石枯木昇華到有靈感的生命。西洋在二十世紀前半期，有許多畫家兼作「剪貼」。他們是剪拼有圖形的「彩印花布」入畫，稱為 collage。步隨其後的畫家開始在畫面上加舊衣、破椅、電視冰箱及各種廢料，作成巨幅，稱為 Assemblage，中文稱之為「綜合媒材」。

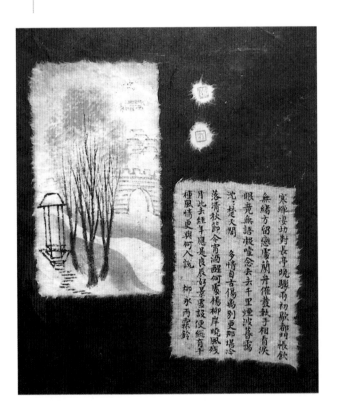

圖27　曾佑和掇畫經過
　　A　十首宋詞之一（柳永）
　　1954　豎英寸15½　橫11
　　初起時只托裱移置。

145

傳統中的現代

B　樹林叢叢
1956　豎英寸28　橫20

C　石
1956

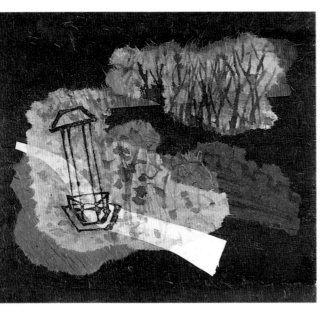

D　十首宋詞之一(同 A 一詞)
1958本　豎英寸11　橫15
用彩色紙入畫

　　我的紙藝起端在出國以前。當時知道出國後要自己托裱畫
件，便在四六、四八年間，到北平德勝門及琉璃廠前後，與師
傅學裱畫。初至檀島時，美術館中無此人手。由我爲館中收藏
修補舊畫及破裂的屏風，將碎紙撕剪細心綴補。在家中又托裱
自己的繪畫，由是逐漸將紙之疏密層次，融入畫中。爲省時間
如今不再自己造紙，因爲知道製紙的步驟，完全運用紙性，收
集所有東方及太平洋各地以植物爲原料的手製紙，這些都屬於
中國製紙漿的本源。至於畫中之著色點染，有時在前有時在後，
經營章法則都用手筆。　中國顏料來自花草極易褪色，　如今用
的是人造不褪色壓克力顏料(acrylics)，仍是加水後極稀薄的敷
施。掇畫之法有四、五種，均有粗細之別，同時還滲用金及錫
箔，細時紙質可混合一片不見縫跡。我特別喜愛紙質，願顯示
紙性。複雜時一幅畫要費數星期之久，盡力不重複我已畫過的

圖28　A　礦產晶石

B　不同的觀點
曾佑和　掇畫　1959　豎英寸48
橫24
此後不再用彩色紙。點染用手
筆。這幅是由晶石中醒悟凸凹多
角形。

圖29 記憶希臘
　　曾佑和　掇畫　1985
　　48英寸四方
　　較繁瑣的作法

圖30 蟋蟀頌
　　曾佑和　1993　30英寸四方
　　較簡單的掇畫

傳統中的現代

章法，使每幅各有特別之境。如果照樣反覆重作，便成了千篇一律，喪失靈魂。如不斷變化，則可以保持每幅畫的生命。

圖31　濕潤
　　曾佑和　掇畫金潛　1964
　　24 英寸四方

　　五〇年代我初作掇畫時，並無其他畫家用東方紙材及傳統補綴法入畫。此後，迅速的在檀島及美國西岸出現許多用東方紙料的畫家，宣言是來自日本。日本一如中國，製紙及實用都很發達。傳統工藝只用為裝飾背景，從未入為畫材。如今紙藝已變化萬端，成為獨立的畫科。我有日期記錄，認為自己是東方新「掇畫」的開拓者。

　　我最近的取景仍有中國山水痕跡，因為山水題材人人皆知，很容易看出我的作品中「別有天地」。我是希望能以山水抓住哲

學本質，再出於意外，不是厚古薄今，而是籠統的蛻化。每個人都有不同的心理，要用自覺的體驗、有生氣的思想，便能開豁內心的空間。藝術的絕妙之境是人造而又能超越凡世。所謂的「神」品，並非天神能化凶為吉，而是「人智」深入如有生命的神靈附身。宋儒了解到：

「神無方，易無體，…有定體則不能變通，非易也。

易雖有體。體者象也。假象以見體而本於無體」⑫

若論藝術之「力」，必以潑辣為上。比如爆炸莫過於原子彈。如蕈的雲頭，可以平千里傷萬眾。我卻認為在未爆發之前原子力連鎖在彈中。表面平平而潛力俱在，比爆發更為隆重。我認為破毀的爆發不是唯一「力」的表現。我畫中的物體似有似無，不是起始也不是結束，在二者之間，自有將成形而尚未成形的起伏，如海底水藻，緩緩的搖擺，如飛禽走獸一同，有個自生自滅的生命。

我的畫體有幾個焦點：

一、是思想的起伏活動。用音樂的板眼、絕句的簡潔，隱喻聯想，開放空間，使之出入收放自如。避免裝飾性的圖案，甜俗的色彩。

二、用平面立體、凸凹明暗視覺上的參差曲扭，往返錯交。不是一目了然，但啟發一種拍敲脈搏，用有限的物體，削減邊界，漫延畫外。

三、簡化的物體有書字的結構。大半隱在畫後，有時出現

傳統中的現代

151

圖32　A　宋　官窯瓷紋

B　西周　原始靑磁罐

畫面。一個字的點劃雖分散，但又能緊湊一體。

　　四、有紙質纖維的托襯，筆跡點染控制動的凝結，如陶器上的流綵，玉器上的斑肌，濃淡偶然。畫面雖定而動態俱存，感覺彷彿在深呼吸，練「功夫」。但其中並非已經靜默定神，而是正在整理心境。

　　簡如上述，以明畫志，兼求敎於海內外藝術方家。

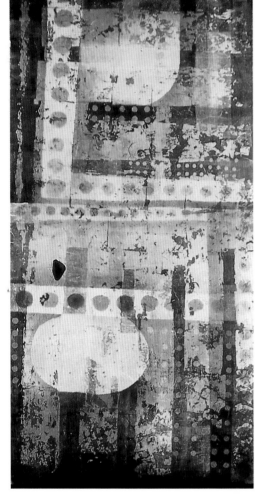

圖33　字的脫化
　　　曾佑和　掇畫
　　A　馬
　　錫箔　1965　豎英寸72　橫36

B　提取形質
1991　豎36　橫34
山前有林字

153

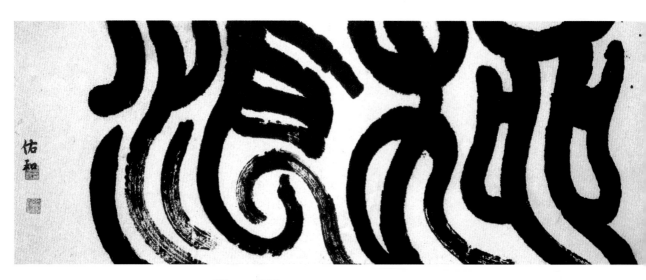

圖34　柳浪
　　曾佑和　1992　豎II英寸　橫24

圖35　實習功夫
　　曾佑和　掇畫　1994　30英寸
四方

圖36　夜半鐘聲
曾佑和　掇畫　1995　30英寸
四方

① 艾克號鍔風（Gustav E. W. ECKE, 1896-1971），德國人。專修歐洲美
學及美術史。博士論文是法國十九世紀、超實派前鋒、查理漫容（Char-
les Meryen Leipzig, 1923）。修學時與「藍騎士」（Der Blaue Reiter）及
包浩斯（Bauhous）學人同時。精通德、法、英、拉丁及中國語文。一九
二三年，福建廈門大學創校應聘來華。二八年，清華創校後往北平。
後輔仁大學創校，轉任，授北歐文學史、西洋美術史。在華定居二十
六年，遍遊中國、朝鮮、日本名勝古蹟，對中國文化藝術欽佩之至，
從事研究著作，終生未懈。創辦《華裔學誌》年刊。並寫著中國金、
石、建築、木具、繪畫等書籍多種。一九四五年婚曾幼荷（佑和、昭
和）。四八年輔仁遷校，復校無期。四九年檀香山美術館聘爲東方部主
任，並任夏威夷大學美術史教授。七一年去世。

傳統中的現代

155

② 赫伯瑞德爵士(Sir Herbert Read, 1893-1968)，英國詩人、教授。二十世紀最重要的美術文藝批評家。寫作甚多。錄自 *A Concise History of Modern Sculpture,* edition 1966。

③ 克利(Paul Klee, 1879-1940)。參考英譯 *The Thinking Eye.* Notebook of Paul Klee, wittenborn 1961。譯自德文 *Das bildnerische Denken*, 1956。

④ 石頭舞樂(Rock Music)興起美國一九六〇年代，至今風行。初期收牛郎及黑人歌調及樂器。八〇年代後歌詞多涉社會不平。普遍電視中及夜總會。近年來時常在戶外搭臺歌舞，音調爆發掀震色情，如瘋如迷。號召青年萬衆，服裝怪異，色彩攝影巧捷，為前衛藝術界欣賞。

⑤ 竹林七賢為晉代的山濤、阮籍、嵇康、向秀、劉伶、阮咸、王戎七人代表中國放情肆意的自由人生觀。

⑥ 紐約市區畫廊(The Downtown Gallery, New York)。活動時期在三〇至七〇年代。畫廊女主人依娣士·何柏(Edith Halpert)專長美國民間藝術。協建美國標準的歷史城 Williamsberg, Virginia, 代理當代美國各畫家多人。

⑦ 「行動派」(Actional Art)接續「抽象表現派」(Abstract Expressionism)最活動時期在四、五〇年代。作品巨大，用強烈動作及色彩。把握剎時的衝動。「書法派」有數系。美國西北、紐約、芝加哥、巴黎各有主動畫家，大都用東方黑白線條。

⑧ 「超實派」(Surrealisme)有歷史淵源。新超實派最活動時期在四、五〇年代。法德等地。傾向夢境幻覺「下意識」的領域。此外尚有多數新派別，各取名銜都是傾向心理的檢討。

⑨ 張載。〈正蒙・大心〉。簡要。

⑩ 邵雍。《觀物外篇下》。卷十二，頁三。

⑪ 程顥。《二程遺書》。卷一，頁十，十一。

⑫ 邵雍。同上。

傳統中的現代

Curriculum Vitae

TSENG YUHO(Betty Tseng Ecke)

EDUCATION

1936-1939 Tutored privately Chinese painting

BA-1942 Art Department, Furen University, Beijing, China

1942-1948 Graduate studies continued at Furen, Beida and Central

three universities, Beijing

MA-1966 Asian Studies, University of Hawaii Manoa, Honolulu

Hawaii

PhD-1972 East Asian Art History, Fine Art Institute, New York

University, N.Y.

PROFESSIONAL AFFILIATIONS

1993 & 94 Guest lecturer, Summer Session of Asian Development,

join project of the East-West Center and American

College Associations

1953-pre Consultant of Chinese Art, 1985-89, Adjunct-Curator,

Honolulu Academy of Arts

1973-86 Professor of Asian Art History, Department of Art, 1971

-73 & 1979-82 Program Chairperson, Art History

1969-73 Associate Professor of Asian Art History, Department of

傳統中的現代

159

傳統中的現代

Art, UHM

1966-67 Fulbright Guest-lecturer of Chinese Art History,

Department of Art History, University of Munich, and

studio course at Academy of Art College, Munich,

Germany

1981-pre Senior Academic Abroad, External Examiner and

Personal Consultant, Art Department The Chinese

University of Hong Kong

1950-66 Instructor of Chinese Painting and History at Art School

Honolulu Academy of Arts, Summer Sessions and

evening Extension courses, UHM

1946-48 Chinese painting and history, Yale-Chinese Language

School, Beijing, China

1942-45 Assistant to Professor Pu Quan and Gustav Ecke

ART HISTORIC EXHIBITIONS,

Organizer, funding, curator and catalogues

1989 TAN-YI, ONE, in recognition of Hawaiian-Chinese

artists on the Bicentennial celebration of Chinese on the

Island, Contemporary Museum, Honolulu, catalogue

pamphlet

—— TAN-YI, TWO, a jury exhibition for residing Chinese

artists in Hawaii, AmFac Plaza Gallery, Honolulu

catalogue pamphlet

——	CHINESE ART IN THE PALM OF A HAND, Honolulu Academy of Arts, catalogue pamphlet
1988	ORIENTATIONS, private collection of members of the Oriental Society of Hawaii, Honolulu Academy of Arts, organizer, research and co-editor of the fully illustrated catalogue
1982-83	POETRY ON THE WIND, the art of Chinese folding Fans, Honolulu Academy of Arts, fully illustrated catalogue, traveled to Santa Barbara Museum of Art and Smart Gallery of University of Chicago
1978	SHOPPING IN CHINA, 19th century gouache painting by Chinese artists in Canton, China, a loaned exhibition from the Museum of American-China Trade, Milton
1977	HAN AND TANG MURAL ART, a large collection of facsimiles from tombs of Xian. People Republic of China, the Art Gallery, Department of Art, UHM
1976	SELECTION, NO. 1, master-pieces of art works selected from private collection in Hawaii, benefit exhibition for the inauguration of the Art Gallery, Department of Art, UHM
1976-78	CHINESE FOLK ART, ONE, commissioned by China Institute of America, New York, NO. TWO, an enlarged selection sponsored by the American

傳統中的現代

161

Bicentennial Committee of Hawaii, Honolulu Academy of Arts, traveled to Asian Art Museum of San Francisco, Los Angeles Country Museum of Art and Field Museum of National History, Chicago

1971-72 CHINESE CALLIGRAPHY, commissioned by Philadelphia Museum of Art, traveled to Metropolitan Museum of Art, New York and Nelson Art Gallery and Atkins Museum of Fine Art, Kansas city

LOCAL, NATIONAL & INTERNATIONAL SERVICE

1950-pre Served more than fifteen committees in Department of Art, inside University system, East-West Center and the Honolulu Academy of Arts
Regular public lectures to various social groups locally, also countless public lectures at national and international art associations, museums and universities, especially during the periods of organized historical exhibitions and also on personal creative art.

1950-pre Members of Symphony, opera, theater, Friends of East-West Center, Alumni New York University, Association of Chinese Scholars in Hawaii, Society of Academy Fellows, Western Museums Reciprocal member Founding members of Contemporary Museum and Annual Partner, Friends (Partner) of the Art Gallery,

UHM, FRAUM Faculty Retired Asso. UH

Life member of Hawaii Education Ass. Founder of

Oriental Art Society of Hawaii

Honorary fellow of Asian Society, New York, China

Institute of America, N.Y. Painting Academy of

Shanghai, P.R. China, President of Chinese Classic

Furniture Ass. Beijing

President of BTYH Foundation of Humanity, Honolulu

1976 Selective Board of National Endowment of Humanity,

Washington D.C.

1987-90 Appointed a member of the Governor's Committee for

the Hawaiian-Chinese Bicentennial celebration in 1989

PUBLICATIONS, Books and articles

1994-article THE COSMIC MIRROR, in *Bronze Mirror in Ancient*

China, catalogue of Donald H. Graham Jr. Collection,

Honolulu

——article WOMEN PAINTERS OF MING DYNASTY, journal

Artibus Asiae, Museum Rietberg Zurich cooperation with

A.M. Sackler Gallery, Smithsonian Ins, Washington in

memory of Prof, AC. Soper, New York-Philadelphia

1993-book A HISTORY OF CHINESE CALLIGRAPHY, the

Chinese University of Hong Kong Press

1992-article in Chinese, PUBLIC COLLECTIONS OF ASIAN ART

傳統中的現代

傳統中的現代

IN HAWAII, Quarterly journal of National

Historic Museum, Taipei, Taiwan

——-article in Chinese, IMPRESSIONS OF CONTEMPORARY

CHINESE INK PAINTING IN THE

INTERNATIONAL MILIEU, vol. 2, special

series on One Decade of Modern Art

Development in Taipei, 1983-1993

1991-article GUSTAV ECKE and APPENDIX TO 'NOTES ON

CHINESE FURNITURE' *Orientations*, Nov. monthly

magazine of art and connoisseuship, Hong Kong

——-preface in Chinese, ON GUSTAV W.E. ECKE, in Chinese

translation of his book *Chinese Domestic*

Furniture, 1946 Beijing

——-article THE IMMORTAL HERMITAGE ON THE PEACH

STREAM, a handscroll painting by Wang Hui (1632

-1720), *Orientation*, Jan. Hong Kong

——-book DSUI-HUA, catalogue and technique of her creative art

on paper by Tseng Yuho HanArt Gallery, Hong

Kong-Taipei

1988-article CHINESE PAINTING OVERSEAS, A PERSONAL

ACCOUNT OF CHINESE PAINTERS OUTSIDE

CHINESE SOCIETY, *Twentieth Century Chinese*

Painting, based on a talk delivered at the Symposium

1987-book ART OF TSENG YUHO, co-author with Howard Link, Honolulu Academy of Arts

1981-preface THE IMPORTANCE OF INK IMPRINT, for Catalogue of *Chinese Rubbing Collection from Field Museum*, Chicago, Fieldiana Anthropology, New Series No. 3, assisted research and consultant

1977-article CHINESE CALLIGRAPHY IN THE 17TH CENTURY, *Journal of the Institute of Chinese Studies*, Chinese University of Hong Kong

1976-articles Three articles on three Chinese painters: Mei Ching, Kuncan and Ting Yun-peng, *The Dictionary of Ming Biography*, Columbia University, N.Y.

1972-article FROM SOME BUDDHIST ART EVIDENCE, A RECONSIDERATION OF THE 6TH PRINCIPLE OF HSIEH HO, CH'UAN YI MO HSIEH, *Preceding of the International Symposium of Chinese Painting*, National Palace Museum, Taipei

1970 & SOME CONTEMPORARY ELEMENTS IN CHINESE
73-book CLASSIC PICTORIAL ART, University of Hawaii Press, two editions

1963-article WEN CHENG-MING, (1470-1559), *Encyclopedia of World Art*, Rome, Italy

Before 1963, a series of five artists in the Ming period (1368-1644)

傳統中的現代

傳統中的現代

published in scholarly periodicals: as *Art Asiatic*, Paris, *Oriental Art*, London, *Art Orientalis* Michigan-Washington D.C. and *Archives of America*, New York

At least six full illustrated catalogues in book forms with original researches on the historic exhibitions, two original information pamphlets, and many short writings for Chinese and English popular magazines and newpapers.

HONORS, AWARD & GRANTS

1993- Award for Best Produced Book in Hong Kong 1993, black & white catagory of English language, Urban Council Libraries Select Committee, Hong Kong

1992-93 On an invitation of the Municipal Museum of Modern Art, Shanghai Museum for a retrospective Exhibition of Creative Painting, then traveled to Beijing, Taipei, Hong Kong and Singapore

1990 Award LIVING TREASURE OF HAWAII, a recognition of artistic contribution, Honpa Hongwanji Hawaii Betruin

1974 Paul S. Bachman Memorial Award, Pacific and Asian Affair Council for outstanding contribution to the relationship of United States and Asia

1972 New York University Foundation Day Honor Award for Outstanding Scholarship for the Ph D thesis, New York

University

—— On his historical visit to China, President Nixon took two specially bound copies of CHINESE CALLIGRAPHY 1971-72, presented to Chairman Mao and Minister Zhou Enlai as token of friendship between the two countries

1966-67 On an invitation of Culture Ministry of Baviria, Germany, granted Fukbright Scholarship one year lectureship in Munich, Germany

1966 Joined Gustav Ecke an award of recess, Rockefeller Foundation, two months at Belagio, Lake Como

1964 Award for book design SOME CONTEMPORARY ELEMENTS IN CLASSIC CHINESE PAINTING, Los Angeles

1963 Two weeks as guest of King of Sweden on the inauguration of his collection donated to the new Asian Art Museum, granted one-person exhibition at the National Museum of Modern Art, Stockholm, Sweden

1960 Louis Horowits Scholarship of the Oriental Society, Washington D.C. study Asian art in Japan, Hong Kong and Taiwan, had exceptional reception from these countries, handled and examined thousands of master-pieces. In Taiwan, at that time the National Palace Museum has not yet consigned in a building,

傳統中的現代

傳
統
中
的
現
代

national treasures were crated in boxes stored in caves

near Taichung. The Museum Director granted me the

unique privilege of opening two crates per day, with two

curators present for two months, handled near four

thousands masterpieces from this Imperial collections

Recipient of many research grants for the various art history

exhibitions, from UH Foundation, National Endowment of Humanity,

Cooke Trust Foundation and many community assistance

SOLE EXHIBITION

1992	Retrospective exhibition traveled from Shanghai Municipal Museum of Modern Art, to National Museum of Modern Art Beijing, Taipei Municipal Museum of Modern Art, Hong Kong Art Center and National Museum of Fine Art Singapore
1989	Honolulu Academy of Arts
1966-67	Kunstverien, Munich, Germany, Reitberg Museum, Zurich and Karmeliter Klostr, Frankfurt, Germany
1963	San Francisco Museum of Modern Art, then to the National Museum of Modern Art, Stockholm, and Musee Cernuschi, Paris
1962	The Downtown Gallery, New York
1960	The Downtown Gallery New York (exclusive agent till 1972), Roster with Georgia O'Keeffe, Ben Shahn, Stuart

Davis Yasuo Kuniyoshi John Marin and other American artists. During these years, the Gallery sent paintings over all states in group shows.

1959 Honolulu Academy of Arts with new Dsui-painting technique, traveled to Stanford University Art Gallery and Walker Art Center, Minneapolis

1957 Edition Euros, Paris

1955 A travel exhibition sponsored by the Smithsonian Institute Travel Divison, show in 10 museums and art centers in the United States

1952 Honolulu Academy of Arts, traveled to de Young Museum, San Francisco, Gallery Fussli, Zurich, Switzerland

1950 Gump's Gallery, Honolulu

1949 Fung Ping-shan Library, Hong Kong University

1946-47 Sponsored by the British Council in Beijing, exhibited in London, San Francisco, de Young Museum now, S.F. Museum of Asian Art

1946 First Sole-exhibition, Beijing Union Medical College Hall, Beijing, China

SELECTED GROUP SHOWS

1984 20TH CENTURY CHINESE PAINTING, City Hall Art Center, Hong Kong

傳統中的現代

傳統中的現代

1983 INAUGURAL EXHIBITIONS, Oversea Section, Taipei
Municipal Museum of Modern Art

1965 50 ARTISTS OF THE 50 STATES, Rockford Museum
of Art, Illinois

—— PACIFIC HERITAGE, Los Angeles, San Francisco, Santa
Barbara and Berlin Festival, Germany

—— IMPACT OF NATURE, IBM Gallery, N.Y.

—— AMERICAN PAINTING BIENNIAL, Corcoran Gallery,
Washington D.C.

1964, 68 PAINTING AND SCULPTURE INTERNATIONAL,
Carnegie Institute, Pittsburgh

1958,60,62 AMERICAN PAINTING AND SCULPTURE, Art
Festival University of Illinois

1958 FRESH PAINT, American Art of Western States,
Stanford University Art Gallery and de Young Museum
San Francisco, won first price

Through 1959 to present joined regularly in group shows
nationally and locally lost count.

LARGE COMMISSIONS

1990 Wall Painting, entrance hall of Betwest Inc. Building,
Honolulu

1981 Wall Painting, Maui Memorial Hospital, State Foundation
of Culture and the Arts

1979 Wall Painting, Honolulu International Airport, SFCA

1973 Wall Painting, Hilo Campus Center, Student dining hall,

 University of Hawaii, SFCA

1967 12 illustrations for the *Analects of Confucius*, The limited

 Edition Club, N.Y.

1964 Large mural, Golden West Saving and Loan Association,

 San Francisco

1958 Mural, Manoa Chinese Cemetery, Honolulu

1956 Stage set for JOB by Dallapiccolas, Juilliard School of

 Music stage designs and costumes of ORFEO by

 Monteverdi, Annapolis Navy Academy theater, and

 opera theater, Washington D.C.

傳統中的現代

曾佑和藝術簡歷摘要

原名昭和，筆名幼荷，1986 年後改寫佑和

1925 年北京生人，父籍河南，光山

1934-36	北京家庭教師繪畫
1942	北京，輔仁大學，美術系畢業
1942-45	溥伒、艾克二教授助教
1942-48	輔大、北大、中大繼續聽課
1945	婚艾克教授
1948	隨夫居廈門一年（艾克爲廈門大學客座教授）
1949	僑居夏威夷，美國
1951-66	授中國繪畫及畫史，夏威夷大學（夏大）及火奴魯魯 美術院（檀島美院）
1966	東亞學碩士，夏大
1966-67	德國白威亞文化部邀請授中國繪畫史，慕尼克大學， 美術史系；中國繪畫法，藝術學院；美國政府扶布萊 國際文化交流學位，一年。
1967-69	紐約兩年求博士學分
1969	回檀島，夏大副教授，美術系
1972	東亞美術史博士學位，美術史研究院，紐約大學
1973	夏大正教授，美術系，1971-73 及 1979-82 兩任美術史

傳統中的現代

　　　　　　　主任

1978-86　　　夏大，中國研究中心主任

1981-95　　　香港中文大學美術史系，校外考試審查及校務

1986　　　　退休夏大課程

1991　　　　退休檀島美院管理主任，繼續中國美術顧問

　　　以下錄自 1986 始，退休前全職任務繁多不錄

現職及服務擇要

1986 至今　　繪畫，著書

　　　　　　創辦檀島東亞美術學會，夏大退休教職員協會

　　　　　　檀島美院助金會會員,檀島現代美術館創立及助金會員

　　　　　　TYH 人文基金會，會長

　　　　　　中國民間藝術協會，會長

　　　　　　輔仁、夏大、紐約大學校友會會員

　　　　　　上海畫院名譽會員

　　　　　　中國古代傢具研究會，名譽會長

歷史美術展覽，籌劃、選件、撰文及編目

1989(88-90)　檀藝 1,檀藝 2,中國掌中珍賞美術等展

　　　　　　省政府聘請爲慶祝華僑入島二百年紀念

1988　　　　東方之光，東亞美術學會，會員收藏展，檀島美院

1988　　　　文人畫，賀請生夫婦收藏明清繪畫展，檀島美院

1983　　　　迎風詩意，折扇展，檀島美院，聖巴拔拉美術館及芝

　　　　　　加哥大學，斯瑪展覽館

個展

1991-92　　　回顧展，上海、北京現代美術館、臺北市立美術館、
　　　　　　　新加坡國立美術館、香港美術中心

1989　　　　檀島美術館

大型壁畫

1995-6　　　祈禱堂，聖本篤教堂，聖約翰大學，明尼蘇達省

1990　　　　密威士公司走堂，火奴魯魯

著書、學術論文

1995-97　　　《中國歷來抽象藝術及抽象觀念》，載美國東亞抽象
　　　　　　　的藝術，展覽目錄，青瑪利美術館，儒各省立大學，
　　　　　　　紐澤西省（英文）

1995-96　　　《中國畫選新語再版》，附第二篇《中國傳統美感的我
　　　　　　　見》（中、英文）

1995　　　　《焚香藝術》，國際鼻烟學會年刊（英文）

1994　　　　《釋中國宇宙六情銅鏡》，中國古鏡圖鑑，唐古安先生
　　　　　　　收藏目錄（英）

1994　　　　《明代女畫家》，載東亞美術年刊，紀念守伯教授九十
　　　　　　　壽辰專刊，瑞士（英）

1993　　　　書學，香港中文大學（英）

1992　　　　《檀香山東方藝術的收藏》，載臺北歷史博物館季刊
　　　　　　　（中文）

傳統中的現代

傳統中的現代

1992　　《現代水墨畫在國際藝壇上的表現》，載臺北現代美術十年（二），美術論叢 51，臺北現代美術館（中文）

1991　　艾克著《中國傢具隨筆》，附文：《略談傢具新訊》，東方美術雜誌十一月，香港（英）

1991　　《序》，中譯本艾克著《中國花梨傢具圖考》（中文）

1991　　《桃花源手卷》王翬畫，東方美術雜誌正月，香港

1991　　掇畫，曾佑和展覽畫冊，香港—臺北，漢雅軒（中、英文）

1988　　《中國繪畫在海外環境中的感想》，載二十世紀中國繪畫討論，香港（英）

1987　　曾佑和的藝術，畫冊，林豪華合著，檀島美術館（英）

獎譽

1993　　書學，本年最佳的黑白出版書，香港市政府圖書館獎狀

1990　　《稀世人傑》，西本願寺美術會，檀香山

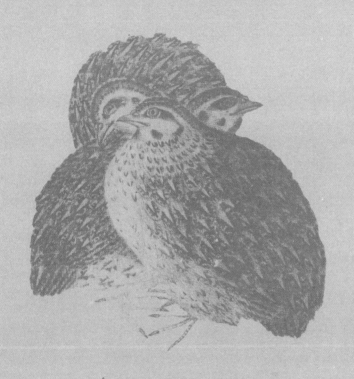

以暴強顯示者。在西洋有范荷開創狂熱畫風。他本人不僅天才、確有神經失常之症。偏巧徐渭朱耷二畫家也有失常病狀、與後期揚州八怪畫壇浪笑傲者又不同。情感抑壓難舒、奔放于其作品、毅力天才相標榜、全無造作。性情必須真摯懇切。

畫四十七。

趙孟頫問錢選：「何謂士氣?」錢答曰：「隸体耳」。恭肅端整、穩而全、篤而厚、似乎傾向中庸道德觀。為中國畫之特色、與前數例有別。

畫四十八。

清呂丰隱山水。全是隸体作風。宋元、董巨一系諸大家多少載有「隸体」品格。山水佈置如靜物擺設。是一種超越客觀態度。七情六慾如枯、其實這種境界如漢斯阿伯「包豪士」一派幾何藝術家、利用物理科學、講理性羅輯因素、其鎮重震與隸氣同。黃鉞以玄理括之：「萬象遠視、遇方成圓。……圓斯氣裕、渾則神全」。

畫四十九。

大黿字、清劉永福書。……雙目瞳三雄如生虎在座。是文智摛住渾沌原力、是人文也不甚分析、起脫自矜自慚、彷彿原始之結繩、至壯至簡、籍為書尾鎮、而畫理則淵兮無窮。

封面、近代畫家楊渭泉作集錦畫

庚午—一九三零年

吾人所仰。此畫全用篆籀筆、與前頁同。櫻桃盆架在畫中的地位是印章的修養。

圖卅九。提起書法與畫法的關係、此後兩舉之例都是書畫相往返的作品。多為簡捷速描。此龍字減筆恰如曲龍。清鄧石如書。

圖四十。明朱耷蘭草。彷彿草書一字。當初上古創文字時、縮俸減形與此僅一線之差。彼為記文達義的符号、此為藝術達意的象徵。

圖四十一。清李鱓墨蘭。中國蘭竹墨戲純是書法。保羅珂雷說：「抽象畫的趨使、是由線條引發。因之以書法描形象者、自然而然便傾向標準化、理想化。必勝於中肯節要。畫家作品愈純者（就是線表現愈型典者）其作品愈缺于描寫皮毛外形之線」。多少新畫家在求中肯撮要的能力。

圖四十二。清鄭燮。胸中逸氣風韻勃發、與花布兩印的不同。順手點来亂而有序。此畫全是平面佈置。是有「機物」與「無機物」之別。

圖四十三。唐草聖僧懷素兩採用。黑地白文的攝乇頗為今代畫家所採用。癲草純筆、風馳電閃、魄力呈顯。以豪放為主。

圖四十四。明徐渭葡萄。縱橫淋漓、放誕之勢不可不了。這種潑辣畫風行今時。

圖四十五。徐渭荷花。有批評家說俏語：「他自由到順從感情的衝動」。過去詩人騷客恊情不羈、借酒肆情、破墨潑墨尤勝表現劇烈。然而與禪家減筆頓悟之洒脫不同。

圖四十六。明朱耷荷花。廿世紀心理以任情淺發為上。於是文藝有

外者多險奇。一絲之勁可敵萬夫。「力」的表現應有種～方式。

圖廿八。商鐘鼎文。象形文字減筆刪體始終與畫未脫離關係。此記字形大小、線條潤細、啟示作家心。章法尤可喜。以

圖廿九。商鐘鼎文。四邊加欄、限界之始。畫字從田從界□。以

圖卅。漢瓦當殘片。文字由象形歷篆籀、發達至全符号的楷書、草書。秦漢磚瓦鏡鐘等工藝也探文字作畫案。六藝之一的文字畫法堅持備畫作用。

手又持木於一有限之區域而成畫。

圖卅一。漢印。印章也是字記分支。兼書畫之長。布局無立侔遠近之分陳鋪面上、陰陽虛實以經營位置為主。秦漢以未有無数奇妙之作。

圖卅二。漢印。畫家自趙孟頫始兼工金石學。併篆刻為修養之一。印章自此供書畫許多巧妙結構。

卅五：刀筆頓銼稀密、無絲毫不謹。一橫一豎、及至文衡山，文三橋父子其風大盛。

圖卅三。近人印章三方。所謂「三遠」位置不同。如此聚精會神、如何不啟發心思。

卅四：或傾或屈、不僅線條粗細斷連有關、空白邊界俱是章法。尺寸之制、陰陽之数」。

圖卅六。印章是小型、變化方寸之中、雖則藝術傳壯感不在乎面積大小。清伊秉綬此書一尺以上、全是印法。

圖卅七。清張廷濟古籀。書法格局邊限不似印章緊湊。然而書畫

圖卅八。近人齊白石篆刻特長。用筆兩相瑋益自不待言。因此其畫佈局精簡用筆準拳、為

圖廿三。

如一抽象雕刻作品。吳縣太湖石全是人造雕石。

明吳彬山水，以小變大、磯石成巨巖。其凹凸四厚薄之狀

猶存立作軀圍。可見中國山水之取材、正在這天就人意

任我取擇之處。下意識的趨取純造形、超過實景詩境的

掩護。畫面抒情有限、正理無窮。

圖廿四。

清石濤海山畫。與一塊岩石相似、是小是大、是真是幻、

明顧凝遠云：「或枯樓積石、与水疏林、如造物兩棄置、

與人裝點絕殊、深情冷眼求其幽意之所在、而畫之生意

出焉」。

圖廿五。

清石濤山水。硬指此景為寫真、則嚼其精矣。重復王微

句：「以寸管之筆、擬太虛之体」、以判軀之狀、畫寸眸之

軀体之狀不一、付與靈魂才能生動。

圖廿六。

山石積侔在清龔賢此幅中便「侔物週流」如行雲。黃鉞謂之

明」「如音樓鈜響、如烟成靄」。

圖廿七。

清梅清作。此幅長窗如揮。

畫史只成就趙松雪鵲華秋色

及此二幅荷葉鈙。其中意趣是芥子園畫譜所不敢言論者。

以上諸作品並不代表其作者平生作風。即使偶得之便是難能可

貴。這便是明季以斫卑職業化作品的主因。須知此類作品、甚至任

何畫家傑作各有其單獨的絕境、只可有一、不可為二。一做便成

晃体。然。

唐張彥遠云：「運思揮毫、不滯於手、不凝於心、不知然而然」。有人取此

法國詩波得烈說：「然則心之指撑不曲委於手措滯」。

又認為作畫應以急捷為上。唯大筆方才「寫意」、而生警悟。腕無停

留則靈無阻礙。以上各組作品證明：神趣至靈意出畫外、手法精

時隨心而之。在乎達與不達、不在速緩粗細。「向內」者取平淡、「向

的見幻。古人愛玉石紋理、未嘗言其所以然。今人以智力求紋色抽象狀況謂之「心理形態」。舊詩有句「蝶來風有致、人去月無聊」。自然無機之物加以人性才有致。無人文便不成為文藝「觸物生情、委情於質、二者異途而一」象形與否尚在其次、其中美感絕非偶然。

清王宸激流畠。拍天沸浪、與前大理石紋異途而一。藉激水悚慄、與約「抽象印象」派不約而同。有限的

宋無頯洞庭秋月水。圓月掛空、天風冷三、萬念俱恢。固然富於詩意。馬克

士昂士時代畫家有一畠與此絕似。線條是波如理。

以上諸例是取畫面的韻節極明顯的。利用重疊返復的音、細察宋元諸大山水家的皴法、各有各的節韵。此間「目中」意味如舌嚐、手撫、樂法、起動如呼吸、伸縮彷彿脈博。

是直覺的「觸感」。

中國愛石之癖起端悠久。史記載漢武帝造建章宮便開篡磯石嵌三山仙島景飾。唐庭圍史自不待言。徽宗建「艮嶽」舉勤國之動集奇石之大成、是連愛石的極點。其後石記石譜不勝枚舉。

至於宋米芾拜石兄、撰石譜、

這種石癖是為其理質、為其形狀詭奇、並不追究像什麼。純粹「形」的嗜好。此畠示一破石坐小石子上瓷盆承之清供案上、是純造形之崇拜。

明宣德御案上、是純造形之崇拜。仙家靈芝、其形怪異與石相等。是菖草果真如意、還是人取其如意？

明朱彝尊藏畠。

明十竹齋木刻石譜之一。以石嵌木座上、洞心弧俸、正

圖十二。南唐宮女墓碑。桃花流水、章法隨石紋而出。此種巧技中國歷代五工最善其長。視玉石形狀方圓大小、顏色佈散、因而成花果魚蟲。自上古商殷幾何線狀之圭壁禮器至近世之鼻烟壺玉垂什物,曲盡其妙。向來這種順形而出的手藝類歸工匠、然而其審密之處、正是文人「神来之」品。

圖十三。清張揖如竹刻石鼓文。金石搨片久為收藏家保重。除其鱗刺之狀、脫落缺實、自成組織、百象窮生、恍然遠近、與近代石印畫相等。此竹刻搨搨片,而再搨、難辯是文是備。作家之心顯而易見。

圖十四。硯背浮雕。硯一宋刻、有乾隆御題。纖裏之形出自石狀。是文是其僅一無二的章法是天助是人智。單純而深厚。是「幾何抽象」的基礎。

圖十五。硯二,為大耳、清朱竹坨收。彷彿荒謬、編擊正著。其有機敏能運石為大耳者必是大家。

圖十六。硯三,為康熙間雕。民間作品善誇大主題,常有似而不似的作法。此硯利用石作原質、石眼成巨星、小島大千壓世。天然人工巧合。乾隆御詩云:「周刻虞章意創新、幾曾上古有龍賓、眼中卻合竞夫句、三千六宮都是春」。乾隆代表一部份後期鑑賞家、對工藝頗好新奇。對書畫文智則不免嫉宮褊退。

圖十七。大理石一方。這種天然畫成因浮紋或因色質、不似而似古有龍賓、眼中卻合竞夫句。清阮元題句詆為如山包如激流是他久為收藏家春愛。

通兩種習慣用法。一為指不曾開化民族的作品。另一種為作品
俱有極「樸拙」的體裁。。民間藝術在東方以技能講是極盡奇巧、也是
有大量文智的滲入。概而言之民間作品是聚集喜襲經驗本乎良
知、無個性表現、但另俱一派純真、有集合的閱歷、水王的相
健氣。天真爛熳不求甚解、尤強象徵、極形式化。自我表現的
創作家。又因之收取其性。

畫八。康熙無欵二婦像。中國人像明清以來近民俗畫。其中人物
據謹呆正、恰是可愛之處。美國格賴悟德便專工這種倔
窘老成之態。

畫九。明吳彬十六應真之一。前者人像還近乎民間畫。以明眼取
樸拙為國畫中不勝其舉。羅漢自貫休後吳彬獨攻其長。
返巧為拙、知雄守雌。羅漢的強篤、正是黃鉞樸拙之頌。

畫十。清女畫家周禧阿羅漢十尊之一。這汁作品細緻如織、但他
有奇關之意。四樹摻搞如蚍蜉、如聖安東尼之誘惑。魔

畫十一。周石鼓文。是中國最古的長篇文字。這種古文供時代畫
家不少新意。殘跛蝕痕儘成章采。當初宋朝宋迪掛素絹
於南牆一數日後絹面凹凹成形。宋迪乃隨勢而成山水。
義國古畫家里歐那多大文齊也曾採用舊牆斑跡。中國書
法絶地境有折釵骨、屋漏痕之意。這都是取「天設地造」、過
跡成形、點手成金之妙。唐王洽潑成章。宋米芾清蓮房
作畫。明王養蒙著草履踐絹而成花卉。如今多少時代畫
家畫平生機智取這偶而天成「不期然而然的作風。

可能通神妙、其意趣高深出於形象之外」，正可為此評語。

畫二、群鼠畫。傳元錢選筆。貓鼠家常經見之微、雞鼠之微其間母愛流溢不如說是「母子畫」。黃鉞說：「氣諧韻出、理將妙歸」。

畫三。魚戲畫。傳元錢安仁筆。「物非物、物映心鏡、而為物化」。凡情細故都有深奧。是德國文豪歌德之語、很有禪家或南華經的味道。經營位置精簡，仍為時代設計之模範。

畫四。四喜畫。為清童鈺戲筆。此畫雖用轉聲、而此四黠是抵干山萬壑。用不著塞天壅地以成全章。黃鉞所謂的「厚不因多、薄不因少、喻妙于微、游物之表」。保羅珂雷說是「藝術不應做明而顯見之物、應富啟發曰所未見者」。表現畫外之意有種種路徑。

畫五。符條。清趙之謙作。晉王徽云：「靈無所見、故所託不動。目有所極、故所見不同。于是孚以一管之筆、擬太虛之体、以判軀之狀、畫寸眸之明。……橫攣縱化、故動生為。一小摺方生靈動嵡、法國黃歸士一生注力靜物摺紙、與此心照。

畫六。三鶉畫。傳宋李安忠筆。三鳥偎擁成一團。設意特妙。羽毛底細紛雜、目啄森然。寥遠、大有「超實物」畫派的奇鬱作風。黃鉞則謂之「苦思內斂、幽況外頌」。

畫七。梅。清錢杜作。通常畫梅、以花姿挺秀為勝。錢杜此畫出自老蓮。虬屈皴結、骨眼睜睜。意義全不在梅花。其高古之意與堅勁有連係。

言及民俗原素、所謂的「古拙藝術」，並不是指作者本身智慧。普

廿、簡潔。

簡先繁、欲潔去小、人方辭費、我一筆了、喻妙于微、游物之表、夫誰則之、不鳴之鳥。

厚不因多、薄不因少、旨武斯言、朗若天曉、務然于胸、使神竭智、

廿一、精謹。

石建奏事、書馬誤四、謹則有餘、精則未至、了後位置、使寸管中、有千古奇。貧于一字、慎之思之、然

廿二、儁爽。

畫諦視、先生光輝、氣偕韻出、皆成滯機。如逢真人、雲中依稀。如相駿馬、毛骨權奇、未理將妙歸、名花午效、彩

廿三、空靈。

鸞朝飛、棚之欲動、落：不群、空芳靈芳、元氣絪縕、骨外合中分、自饒韻致、非關烟雲、香鈞爐火、不火而薰、雞鳴桑顛、清揚遠聞。

廿四、韶秀。

畫因韶誤、疏神密、嫩為秀歧、但抱研骨、如濟墨海、此為之涯、媚休憎面娃、有如艷女、有韶秀。如佳兒、非不可愛、大雅其嗤。

（錄自美術叢書）

釋畫

畫一。宗無欸玉奴畜。

中國畫講究線條、此畜雖工細、並不以線條誇張。主題形似、在院畫中是注重的、但此畫使人佩服之處不在逼真。這張畫的長處是作者本身與動物的天真融洽而為一。童稚癡純、彷彿阿利思漫遊奇境記中之貓、西遊記中的猪八戒。保羅·珂雷說：「畫法精練到極處

12

十二、淋漓。
風馳雨驟、不可求思、蒼、茫、我攝得之、興盡華滋而返。味貪則神疲、毋使墨飽、而令筆飢、酒香勃鬱、書此時一揮、樂不可支。

十三、荒寒。
邊幅不修、精采無既；粗服亂頭、有名士氣、野水縱橫、亂山荒蔚；蒹葭蒼、白露晞未、洗其鉛華、卓爾名貴、佳茗留甘、諫果回味。

十四、清曠。
霄之鶴、映永之梅、意所未設、胡為也哉。皓月高台、清光大來、眠琴在膝、飛香滿懷、沖筆為之開、可以藥俗、可以增才。

十五、性靈。
本自根、亦經亦史、淺闚若成、深探匪止、聽其自然、法為之死。譬之詩歌、滄浪孺子。耳目既飫、心手有喜、天倪所動、妙不能已、自。

十六、圓渾。
亦造化、理無二焉、斯途其先、圓以寫天、萬象遠視、遇方成圓、和光熙融、物渾則神全、畫。

十七、幽邃。
理不足、而境是求、脫有未得、擴之以游。山不在高、惟深則幽、林木在茂、惟健乃修、毋兩筆不逌、息之深。

十八、明淨。
人明裝、華娟研、而有未是得、脫塵亭枕流、荷花富秋、紫鷺的的、碧潭澄然、神留于幽、淨與花競、明。

十九、健拔。
足用克、神警骨峭、軒然而來、憑虛長嘯、大往固難、細爭水浮、入尤要、頰上三毫、裝楷乃笑。劍拔弩張、書家兩詬、縱筆快意、畫亦不妙、伫。

四、蒼潤。
妙法既臻、菁華日振、氣厚則蒼、神和乃潤、不刻而儁、空翠黏鬉、介乎跡象、尚不非精進。

五、沈雄。
如松之陰、匠心斯印、目極萬里、心游大荒、名將臨敵、日亦可方、塊力破地、天為之昂、駿馬勒韁、詩曰魏武、書之無遺、括。

六、冲和。
暮春晚露、母鋪其糟、加被五味、拳之可見、賴霞日消、風雨虛鐸、籟過洞簫、三因意驕。

七、泪遠。
白雲在空、好風不收、歸真返真、寓簡以靜、於時為秋、求之已遙、得非力致、失三、嘯歌悠然、寄心於身、譬彼冬嚴、乃之鮨憂。

八、樸拙。
大巧若拙、知有古人、寓樸返真、歸顯於晦、若疾乍瘳、望之心移、即相言彌親、聚精會神、瑤琴罷揮、簫過細流、偶、草衣卉服、如三代人、相。

九、起脫。
硯坐對、縱其性靈、峨峨、意趣高妙、腕有古人、機無留停、意置身空虛、誰為戶庭、遇物自肖、殼、象自形、和于春。

十、奇闢。
思内歛、幽況外頜、極其神如、天為破慳、洞天清閟、蓮菩、造境無難、以手扣扉、舍書法大好、啟其神關、猶之理徑、繁蕪用刪。

十一、縱橫。
一筆耕、況一筆掃、天地古今、出之懷抱、游戲拾得、終、積法成築、是有真宰、而敢草、匪夷所思、勢不可了、曰、不可休。

真理、畫面自然高卓新穎，因此這種純創作不論東西南北常有萬象歸一的可能。能獨出創有意義的作品而後成大家。李手真理才能超脫人去遷變，不受時間地區的限制，永恒於人類美術史。附證有黃鉞的廿四畫品。黃鉞的意見也早有所本，推起淵源不勝其數。不過他寫的簡潔籠斷，證明中國畫直至近古是理性追求，象外之性德。不是胡塗如何與古人同貌一模。斥較筆墨是由筆墨之得全成象外之性德。不是胡塗如何與古人同貌一模。講作品的「正果」不在定法立則。近代瑞士畫家保羅、珂需說：「吾人每以道德觀念形容美術作品」。此說雄合乎中國歷代書畫鑑賞觀。但此中有時是撰辭句的區別。廿四畫品固然有其時代性、細嚼其中基本美學、儒家理智「知覺」、不下於道及禪之玄脫。

按：黃鉞、芳西齋、肖左、左君、左軍、左田、安徽、當塗人。乾隆庚戌進士，戶部尚書。善書、工詩支、篆刻，亦善畫。生於一七五零年，故於一八四一。著有壹齋集、附畫友錄、廿四畫品等。

二十四畫品　　當塗黃鉞著

一、氣韻。
六法之難、氣韻為最、意居筆先、妙在畫外、如音棲絃、如烟成露、天風泠泠、水波瀲瀲、体物周流、無小無大、讀萬卷書、庶幾心會。

二、神妙。
雲蒸龍變、春交樹花、造化在我、心耶手耶、驅役衆象、不名一家、工似工意、兩無衆譁、偶然得之、夫何可加、學徒皓首、茫無津涯。

三、高古。
即之不得、思之不至、寓目得心、旋取旋棄、繡金仙書、搨石鼓字、古雪四山、充塞無地、羲皇上人、武知其意、既無能名、誰洩其秘。

的作品才是畫史中的精華、是有供獻的美術、超越時代及國際之
範圍。

此冊中收集的幾個例子、其中有兩個選擇的原則。一是取畫面
的直覺感、專研究畫的與不專研究的都可以馬上看出它優越之照。
在中國畫內可屬秀慧外展的一類。二是偏重於唐宋以後的作品。
中國畫理自唐以來發達全盛、其間創作精神不容繁言。中國畫論
一向是積極趨向形上學。「不重形」、「不重理」。因此重理則創於
「中國禪理是講究消滅知覺」、中國美術則創於知覺與不知覺交互之
間。此事實不論古界什麼美術佳作、都是出乎知覺與不知覺之間。這種創
作奇才來自天然、作家自己不介意也不分析。這種作品最顯著的
如民間工藝與上古工藝。其中無名藝術家有驚心動魄的作品也不
自炫。第二種是文智的推動。中國畫的主幹受文人薰教自唐以來
是近乎天真而達到一種下意識的地步。新派畫家也是經知覺的
後期潛伏的源淵。但其中偏傾理力既使中國畫中的
「神品」是近發自天真而達到一種下意識的地步。新派畫家也
是經知覺的後期潛伏的源淵。這是道家、禪家參測的

實是發自「知覺」而達到「神品」是近發自天真而達到一種下意識的地步。
歸回於「無」、不是嬰兒原始的「無」。與上古民間的創作是兩種天真。
「無」、如今一般人每以為抽象畫是廿古紀西洋的新發明。但美術歷史
證明自古以來各系文化都有抽象的企圖。「不求形似」之說晉唐已開
其端。現在畫壇新風氣、輕易「前無古人、後無來者」創新革奮的
開山臭祖。比起一般依賴先人的態度同樣有弊。真正創作家追究

中國畫選新語　　　　曾昭旭务荷撰并書

人立受遷、美術標準觀見也隨人事遷動、我們生於廿世紀、達
背不起時代的演進、由於世界交通印刷接觸頻繁、美術範圍為之
開放、我們令人與古人一樣譚：的求美術真理。只是有時不免，以
管窺豹」，或是「削足就靴」順手定論豈不可惜。

過去有美術理論家、比較中國畫的筆墨與歐洲十六世紀的銅版、
與後期印象派的前進畫家、都深受東方禪理書法的影
靜物與中國畫中的瓜果、清供瓶花、有同感。現在所謂的美國西北派紐約派巴
木版畫認為有相似之處。義國的凱若瓦签、法國的沙但、賽古等、
黎的書法派、動派、不計其數非常相近。中國畫中的缺法點撮、
的畫面上是畫理上、是古是今、是東方是西方、我們總
寓不是畫理上是畫理上、是古是今、是東方是西方、我們總

可以找出其中相同之處不下於彼此相異之處。
法國詩人阿波羅列論文藝作風說：「汝豈能終日肩荷汝父之屍！
這句話紐約畫家反對泥古守舊的口頭禪。其實石濤也說過很相
同的話：「古人之鬚眉不能生在我之面目、古人之肺腑不能安入我
之股膽」。「經驗必須要本身體測才深厚、性情發自衷心才能真切。如果
如果令人只管盲目追古求今、不管是古是今到手便成死屍。如果
今人能心通神會、不論求形求理、取古取今、都是泉源活潑無竭。
無己。

這本小書主旨是舉出中國畫中之妄界性、不能庇攬兩有國畫
的成就。也不能包括所有現代畫不約而同的作品。至於哲理心
理邏輯上對教之審、更不能詳細檢討、這只不過是選幾個例、代
表遇去中國畫家創作的探試、不與囚縛成規者同論。只有深造原理

序言

這本小畫冊原是五年前的一個演講稿、只是部局的選材及論理、
推析不持斷言、仍以抒情態度引證、難免威夷大
學印書主任及檀島美術院長慈遜、乃至製版、雖說是小畫冊、印
刷期間竟牽連三四年之久、毛瑞士夫人熱誠編輯、為方便讀者、
求通解減註腳、因之中英兩部字句頻有參差、好在內容高緻合。
關於書畫原件收藏者、多數零散不知下落、故宮一部古物承蒙
準許應用、多謝莊尚巖先生。畜八二婦畜、檀島美術院藏□畜十
七大理石豎屏、曾憲七先生藏、封面集錦畜、林遠梯夫婦藏。照
像師為美術院佐藤政雄先生、中文是著者手抄。

正當出版、胡適之先生訃聞抵此、先生於學術思想不辭入湯蹈
火、按時獎加指摘。正因嚮往之眾、謗譽交加。偶與先生談國畫
現狀、聆先生於中國學術上以進為守的苦心、就學者精神論、無
先生前導、中國文藝不能愛闢新田地、先生以身作則、能化古能
創今、能說能做、一生隆大供獻、中國文藝演進自有實證。謹以
此冊呈獻為
先生紀念追悼。

曾幼荷謹識 檀香山 一九六二年

中國古
語新選

附録

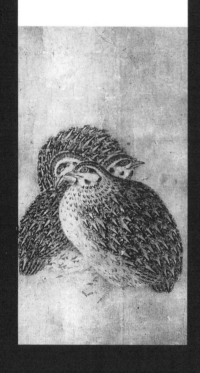

讓熙攘的人生　妝點翠微的新意

滄海美術叢書

深情等待與您相遇

藝術特輯

◎萬曆帝后的衣櫥—— 明定陵絲織集錦　　王 岩　編撰

◎傳統中的現代—— 中國畫選新語　　曾佑和　著

◎民間珍品圖說紅樓夢　　王樹村　著

◎中國紙馬　陶思炎　著

萬曆帝后的衣櫥——

明定陵絲織集錦　　　王 岩　編撰

　　由最初始的掩身蔽體，嬗變到爾後繁富的文化表徵，中國的服飾藝術，一直就與整體的環境密不可分，並在一定的程度上，具體反映了當時的政治、社會結構與經濟情況。明定陵的挖掘，印證了我們對於歷史的一些想像，更讓我們見到了有明一代，在服飾藝術上的成就！

　　作者現任職於北京社科院考古研究所，以其專業的素養，結合現代的攝影、繪圖技法，使得本書除了絲織藝術的展現外，也提供給讀者豐富的人文感受與歷史再現。

藝　術　史

儺ぅご史──中國儺文化概論　　　　　　　林　河　著

　　當你的心靈被侗鄉苗寨的風土民俗深深感動的時候，可知牽引你的，正是這個溯源自上古時代就存在的野性文化？它現今仍普遍地存在於民間的巫文化和戲劇、舞蹈、禮俗及生活當中。

　　來自百越文化古國度的侗族學者林河，以他一生、全人的精力，實地去考察、整理，解明了蘊藏在儺文化裡頭的豐富內涵。對儺文化稍有認識的你，此書值得一讀；對儺文化完全陌生的你，此書更需要細看。

五月與東方——

中國美術現代化運動在
戰後臺灣之發展（1945～1970）　　　蕭瓊瑞　著

　　「五月」與「東方」是興起於戰後臺灣畫壇的兩個繪畫團
體；主要活動時間，起自1956、1957年之交，終於1970年前後；
其藝術理想與目標爲「現代繪畫」。

　　本書以史實重建的方式，運用大量的史料和作品，對於兩
畫會的成立背景、歷屆畫展實際作品，以及當時社會對其藝術
理念的迎拒過程，和個別的藝術言論與表現，作一全面考察，
企圖對此二頗具爭議性的前衛畫會，作一公允定位。全書近四
十萬言，包括畫家早期、近期作品一百餘幀，是瞭解戰後臺灣
美術發展的重要參考書籍。

中國繪畫思想史

高木森　著

　　在漫長的持續成長過程中，我們的祖先表現了高度的智
慧。這些智慧有許多結晶成藝術品，以可令人感知的美的形式
述說五千年來的、數不盡的理想和幻想。

　　藝術思想史正是我們把握古人手澤、領會古聖先賢明訓的
最直接方法，因爲我們要用我們的思想、眼睛，去考察古人的
思想、去檢驗古人留下的實物來印證我們的看法。本書採用美
術史的方法，從實際作品之研究、分析出發，旁涉文獻史料和
美學理論，融會貫通而成，擬藉此探究我國藝術史上每個時期
的主流思想。

　　本書榮獲81年金鼎獎圖書著作獎。

藝術論叢

唐畫詩中看

王伯敏　著

　　本書包括：從對李白、杜甫論畫詩的整理剖析，使得許多至今見不到的唐及其以前的繪畫作品，得以完整地呈現出來；以及作者對於中國傳統山水畫所提出頗具創見的「七觀法」等。
　　全書融和了美術史家、詩人、畫家的觀點，由詩中看畫畫中論詩，虛實之間，給予雅愛詩畫者積極的啓發。

藝術與拍賣

施叔青　著

　　自1980年代初期至今，由於蘇富比與佳士得公司積極投入中國古字畫、當代書畫、油畫拍賣，使得中國藝術品的流通體系更加多元而健全。

　　本書作者以藝評家的犀利眼光、小說家的生動筆法，整體地掌握了二十世紀末中國藝術市場的來龍去脈，是第一本有關中國藝術市場及拍賣生態的專書，讀罷可以鑑往知來，是愛藝者、收藏家、字畫業者必備的寶典。

推翻前人

施叔青　著

　　本書作者傾十數年之功，將她在藝術上的真知絕學，向藝壇做一整體的展現。包括了她多年來所訪問的數位大陸當代藝術大師，對他們的成長、特色、思想、生活，有深入的剖析、獨到的見解；同時也對臺灣當代藝術提出中肯的建言及反省。字裡行間，流露出非凡的鑑賞力與歷史的透視力，一洗前人的看法，樹立了二次大戰後新一代的聲音。

馬王堆傳奇

侯良　著

　　1972年（民國61年）大陸湖南長沙馬王堆漢墓的挖掘，震撼了世人的心眼。因為除了各種陪葬的器物、漢簡、帛書、帛畫的出土外，尚有一具形貌完備的女屍，以及令人著迷的挖掘傳說。

　　本書圖片精彩豐富，作者具有專業素養。他以生動的筆法，為您敘說馬王堆一則則神祕離奇的故事；帶您進入悠遠的世界──漢代，領略她的文學、藝術、風俗、醫藥、科技、建築……等，使蒙塵的「活歷史」，再顯豐厚的人文內涵！

讓美的心靈

隨著情感的蝴蝶

翩翩起舞

綜合性美術圖書

扇子與中國文化

莊申　著

　　在長達三千年的時間裡，扇子一直是中國社會各階層普遍
使用的日常生活用品。可是到了本世紀，由於生活型態的改變
，扇子的使用，已經到了急遽衰退的階段。基於對文化傳統的
一份關懷，作者透過對藝術、文學和史學資料的運用與分析，
讓讀者瞭解到扇子在中國傳統社會中，及中西文化交流史上，
曾經發揮的功用。

　　全書資料豐富，圖片精美，編排尤具匠心，榮獲首屆金鼎
獎圖書美術編輯獎。

古典與象徵的界限——

象徵主義畫家莫侯及其詩人寓意畫　　李明明　著

　　本書經由對法國畫家莫侯及其詩人寓意畫的介紹分析，來
探索古典與象徵這兩種理想主義，在主題與形式方面的異同，
而莫侯的藝術表現，在象徵主義中深具代表性。

　　特別值得一提的是，作者從資料的蒐集到脫稿，前後共花
了六年的時間。以其留法的、深厚的藝術史學素養，再加上精
勤的爲學態度，相信對於想要瞭解象徵主義繪畫藝術，及畫家
莫侯的讀者而言，此書該是您的最佳選擇。

實用性美術圖書